MONTANA

BEER

MONTANA

BEER

A GUIDE TO BREWERIES IN BIG SKY COUNTRY

RYAN NEWHOUSE

FOREWORD BY SENATOR MAX BAUCUS

AMERICAN PALATE

Published by American Palate
A Division of The History Press
Charleston, SC 29403
www.historypress.net

Front cover: Photograph by Carol M. Highsmith. *Courtesy of Carol M. Highsmith's America, Library of Congress, Prints and Photographs Division.*

First published 2013

Manufactured in the United States

ISBN 978.1.62619.021.4

Library of Congress CIP data applied for.

For my beautiful wife, Jess, who has never failed to be by my side or support my hobbies, endeavors and dreams,

CONTENTS

CONTENTS

FOREWORD

With more small craft breweries per capita than nearly anywhere else in the country, Montana is demonstrating that there's no limit to what we can accomplish when we combine our world-class work ethic and entrepreneurial spirit with some of the finest grains on the planet.

Our small craft brewers are proud examples of Montanans doing what they love, creating jobs and investing in their communities while making remarkably great-tasting beer with Montana's blue-ribbon barley.

We, in Montana, are outdoors people. We love to hunt, fish, hike, camp and explore our unparalleled landscapes. I'm proud to see the creativity our small craft brewers are using to memorialize the places we hold dear. Whether it's Tamarack Brewing Company's Rocky Mountain Front Heritage Ale, Blackfoot IPA made in Helena or Madison River Brewing Company's Salmon Fly Honey Rye, our small brewers are putting Montana places and our way of life on the map while making some of the best-tasting beer in the world.

Breweries are going the extra mile to put Montana on the map. People are traveling to our state to enjoy our pristine open spaces and taste our distinguished beer in family-run breweries.

Now with efforts underway to produce commercial hops in Montana, there's no limit to our state's ability to create innovative brews from start to finish.

Hundreds of new Montana jobs are supported by our state's cutting-edge craft brewing industry. It's the perfect complement to our rich agriculture

heritage. That's why I helped found the Senate's first Bipartisan Small Brewer's Caucus.

I'd like to thank Ryan Newhouse for documenting both the history of brewing in Montana and its promise for the future.

Throughout my years representing Montana in Congress, as often as possible, I like to spend a day working at various Montana businesses. I've done everything from building highways and houses to waiting tables and driving eighteen-wheelers.

So on your next stop at a local brewery, don't be surprised if you see me taking your order. I'd be glad to pour you a cold one.

<div style="text-align: right">

All the best,
Max Baucus
Montana U.S. Senator

</div>

ACKNOWLEDGEMENTS

This book has surprised me more than it might the reader. After every conversation with every brewer or brewery owner, I sat still for a moment, impressed by their vision, their fortitude and their sheer love for what they do. It happened every time. So I would like to thank them for giving me those moments. I am fortunate to have had the journey of piecing these stories together as if I were sitting in their brewery meeting a new friend.

I would like to thank the friends with whom I do share beers. Firstly, Alan McCormick, an exceptional beer blogger who writes Growler Fills: Craft Beer Enthusiasm and with whom I discuss many craft beer topics. He is also a talented photographer responsible for some of the fine shots you will find in this book. I also thank my friends Adam, Eric and Rachel for sharing too many good beers with me. It has been fun finding new beers with them.

I want to thank Senator Max Baucus (D-MT), not only for taking the time to write kind words for this project but also for his contribution to preserving the craft beer industry as a whole, including its many tangible and intangible connections. And I'd like to congratulate him on his upcoming retirement.

I must thank my family in Tennessee for being willing to try whatever beer, wine or cider I brew and open when we see each other. They are always polite with their reviews.

I appreciate all the hard work by the staff at The History Press, especially my editor, Will McKay.

In a broader scope, I want to thank my Missoula community for embracing this craft beer "boom." It gives me something to write about.

Last, yet not least, I owe great thanks to my wife, Jessica Redding-Newhouse, for being excited when I am excited and always wanting to try a sip of what I'm drinking. I have no doubt our kids will grow up and be awesome like her and because of her.

INTRODUCTION

As the early homesteaders of the late nineteenth century first dug into Montana's soil to carve out new lives, they did so by utilizing every nearby resource they could find. They tilled, chopped and carried small pieces of the Montana landscape to make a home, to make a life. They relied on the rivers and fields for food and work. They made something out of nothing.

By 1910, agriculture was Montana's booming resource, generating more income at the time than mining. The state's population surpassed 376,000 (and nearly hit 770,000 by 1918), and more than 26,200 farms were in operation. Dozens of new towns like Wolf Point, Glasgow, Malta, Havre, Plentywood, Scobey, Jordan, Rudyard, Ryegate and Baker appeared out of thin air. As did the breweries.

By 1900, only eleven years after Montana became a state, twenty-one breweries were in operation, and a report by the state's industrial board that same year named breweries as one of its most important industries. In fact, that government publication claimed, "In the near future Montana will be one of the chief beer producing states in the nation," simply because of the pure water and superior barley grown here.

As the nation saw an influx of immigrants after the Civil War, many traveled west and were well versed in the brewing arts of their homelands. Thanks to the Homestead Act of 1862, the Enlarged Homestead Act of 1909 and the millions spent on advertising the region by transcontinental railways like the Northern Pacific, the Great Northern and the Milwaukee

Road, Montana became very attractive to new immigrants, particularly to Germans and Scandinavians—two cultures with long and rich brewing histories. In fact, in only a few short years thirty-two million of Montana's acres passed from public to private hands.

As an industry, brewing beer had not changed for many centuries, and small breweries were not yet shackled by strong competition; that would come post-Prohibition. Those with a little capital and knowhow could erect a brewery beside a mining camp, along a river or near a cattle trail, serving the "universal beverage," as beer was known then, to traders, trappers, miners and stockmen.

Today, Montana ranks second in the nation for breweries per capita, just behind Vermont, though it is expected to top the chart by the end of 2013 when at least three more breweries are expected to open.

However, Montanans don't just brew beer; we drink it. According to the Beer Institute, an organization formed in 1986 to represent the beer industry before Congress, state legislatures and public forums, Montana is one of three states where the average annual consumption of beer per adult is over forty gallons, and collectively, we consume nearly thirty million gallons of beer a year.

Beer in Montana is still the "universal beverage." From skiers, trout bums and hunters to farmers, college students and retirees, adults in this state enjoy sitting among one another and swapping stories over a few cold ones. It is a part of our human nature—to share our stories.

That is what I have attempted here in this book—to share the stories of the brewers who create craft beer for their communities. Each brewery in Montana is unique, yet each opened its doors because of a desire to brew good beer. What was either quickly realized or confirmed for these brewers after opening is that Montanans are some of the most loyal people on the planet, and they will dig their heels deep into the dirt to help a good business succeed.

I am honored to count myself among them.

Noteworthy: Based on a law passed in 1999, Montana breweries that produce between one hundred and ten thousand barrels of beer per year are allowed to sell no more than forty-eight ounces of beer to a patron in a day for on-site consumption, between the hours of 10:00 a.m. and 8:00 p.m. Growler fills for off-site consumption are not included in this restriction. Breweries that produce more than ten thousand barrels a year are not allowed to sell beer in their taprooms.

CHAPTER 1
MONTANA'S BREWING TRADITION

THE GIANTS

Glacier Brewing Company owner Dave Ayers says it best: "When I brew, I feel like I'm standing on the shoulders of the giants who came before me." Montana had many giants during its now 150-year history in the beer industry. From the first batch brewed at the H.S. Gilbert Brewery in Virginia City in 1863 until Great Falls Breweries, Inc. pushed its last can of Great Falls Select off the line in 1968, marking the end of the last brewery not only in Montana but in Idaho, North Dakota and Wyoming as well, the breweries that gathered the grains, malted for the mash-in and heaved hops over boiling kettles all left their marks in the tapestry of Montana beer. Whether it was to brew beer to quench the thirst of hard-working miners and loggers or to serve as a public meeting hall or occasional wedding chapel, the brewery was the pulse felt and fed by its community.

So how popular was beer in Montana? In 1902, Montana breweries were turning out five million barrels of beer, roughly twenty-one gallons for every resident in the state at the time (including children).

On the national level, Montana's brewing past can be traced forward to some of the biggest names in brewing today. For instance, before Miller Brewing Company took the name "High Life" in 1903 for its pilsners, High Life was a Montana brand from the Capital Brewing and Malting Co. in Helena.

And Olympia Brewing Company's famous slogan, "It's the Water," was first used in Montana by the Red Lodge Brewing Company for its Glacier

Beer. It later traveled to Tumwater, Washington, via Leopold Schmidt, the German immigrant who owned Centennial Brewing Company in Butte and who would found Olympia Brewing.

And one that hits even closer to home ties into the Pabst Brewing Company (since a grocery in Missoula prides itself on selling the second-highest amount of Pabst Blue Ribbon cans in the United States in 2012). At one time, Pabst Brewing Company beer was bottled in Troy, Montana, so the Milwaukee-based company could avoid paying a tariff for transporting beer across state lines. And coincidentally, Christian Best, the nephew of Pabst founder, Colonel Jacob Best, ran the Kalispell Malting and Brewing Company until 1913 and sold the popular Best Beer brand. The insignia on today's cans of Pabst Blue Ribbon with the letter "B" refers to the Best family.

In Montana, the notion of "buying local" was important even in 1898. In a famous advertisement written for the Schlitz Brewing Company of Milwaukee, the brewery offered anyone $1,000 if he or she could prove its beer had anything other than hops and malt. In retort, the Kalispell Malting and Brewing Company, which incorporated in 1894, released its own advertisement offering anyone a $1 million reward if they could prove "that it is better for the people of Flathead Valley to send money for beer to Milwaukee, when a better article is made at home by Flathead County taxpayers from their own barley, fuel, ice and labor." The Kalispell Malting and Brewing Company went on to produce twelve thousand barrels of beer a day by 1910, and when it finally closed in the mid-1950s, it was the city's oldest business, proving that Montana's communities could be counted on to support their "home brew."

Though Montana has thirty-seven breweries in operation today, ranking second in the nation for breweries-per-capita, at one time there were at least sixty independent breweries making beer, some in towns that do not even exist anymore. And thanks to the continuing research efforts of brewing historians like Steve Lozar of Polson and Jim Peter of Billings, we are uncovering more and more layers of Montana's rich beer history every day. Who knows what previously unknown bottle will be unearthed next?

THE GHOST

It is widely believed that the first established brewery in Montana was the H.S. Gilbert Brewery, built in 1863, though there may be evidence of a

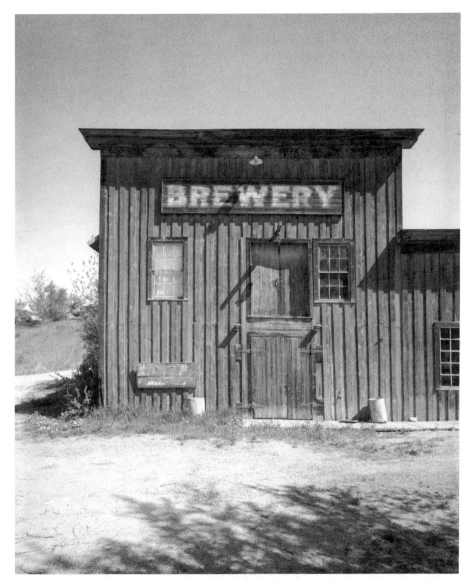

The H.S. Gilbert Brewery is the oldest recorded brewery in the state, dating back to 1869. *Courtesy of Library of Congress.*

brewery on Cottonwood Creek, south of Livingston, which was built by Johnny Grants in 1859. However, most accept the H.S. Gilbert Brewery in Virginia City as the state's "first," and the designation may have more to do with tax records than anything else.

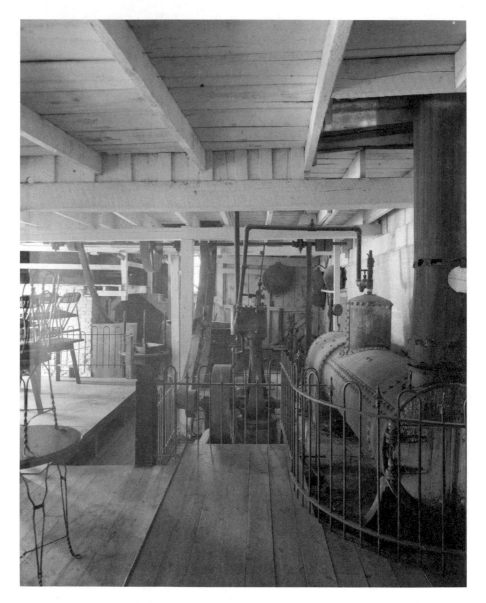

Dining area and brewing equipment inside the H.S. Gilbert Brewery in Virginia City, Montana. *Courtesy of Library of Congress.*

The H.S. Gilbert brewery was originally founded by Charles Beehrer, who then called it the Virginia Brewery. As the story goes, Beehrer arrived in Virginia City on July 1, 1863, and brewed his first batch of beer. When it

was done, and with no more than twenty-five cents in his pocket, he carried the twenty-two-gallon keg of beer to the town saloon and sold it for eighty-eight dollars, marking the first recorded sale of beer in the state of Montana.

Henry S. Gilbert and Christian Richter came along three years later in 1866 and purchased the property for $14,000. The two men operated the brewery together until 1872, when Gilbert bought out his partner and changed the name to H.S. Gilbert Brewery. By trade, Gilbert was not a brewer. He was a saddle maker originally from Berks County, Pennsylvania. He came out to Montana after brief stints in Indiana, Missouri and Kansas, followed by Wyoming, including Fort Laramie. He arrived in Virginia City in 1863 and tried mining. When he and Richter bought the brewery, he relied heavily on Richter's experience to brew beer. Richter was a German-born immigrant trained as a cooper and brewer. Before moving west, he worked as a coal miner in Pennsylvania. After Gilbert bought him out, he pursued stock ranching in the Madison Valley before dying in 1899.

Before Gilbert passed away in November 1902, he had served as mayor of Virginia City for two terms. One of his fifteen children, Valentine Gilbert, succeeded him in running the brewery from 1904 until Prohibition closed it down. There were a few unsuccessful attempts to revive the brewery, mainly by producing soft drinks, such as "Iron Brew," but there was not enough business to support the endeavor.

In its day, however, many claimed that the H.S. Gilbert brewery produced some of the finest beer in the world.

A Million Glasses a Day

"A Million Glasses a Day—Someone Must Like It!" stated the Centennial Brewing Company's slogan in 1905. In truth, that slogan was not far off, as the residents of Butte did enjoy the company's beer. At the time that Centennial was at its peak, so were Butte's other four breweries: the Butte Brewery, the Tivoli Brewery, the Silver Bow Brewery and the Olympia Brewery (different than Washington's brewery).

After the Civil War had ended, miners migrated to Butte, many of which came from the beer- and hop-producing areas of Europe. They brought their affection for lagers, pilsners, bocks and alt beers, as well as the skills to make them. Around the turn of the century, Butte also experienced an influx

Centennial Brewing was once a pillar in the Butte community. *Courtesy of BreweryGems.com.*

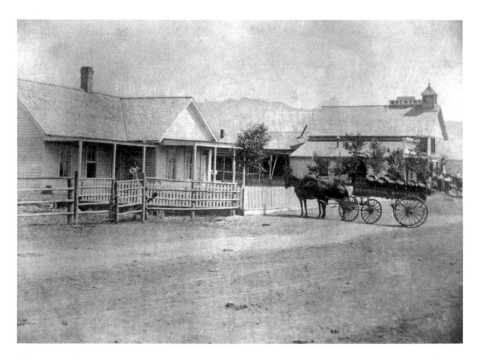

Schmidt & Gamer's Centennial Brewery in Butte, Montana, circa 1880. *Courtesy of BreweryGems.com.*

of Irish immigrants who further contributed to the area's beer industry, though mostly as patrons.

The Centennial Brewing Company incorporated in 1888, with Leopold Schmidt, a German immigrant who built custom coffins, serving as president of the company. Prior to incorporation, the brewery was a three-

way partnership between Schmidt, Daniel Gamer and Raymon Saile. Production was about five hundred barrels a year until 1880, when the company erected a three-story malt and brewhouse, allowing production to jump up to six thousand barrels a year. For its time, the malting facility at Centennial Brewing was the most complete and best appointed in the entire Northwest.

Eight years after the incorporation, in 1896, Henry Mueller and H.C. Kessler purchased Schmidt's interest in the brewery, leaving Schmidt free to move to Washington state. There he founded the Capital Brewing Company, which drew its waters from the artesian wells near Tumwater and would later become the famed Olympia Brewing Company. The horseshoe logo found on Olympia cans and Centennial Brewing labels is part of Schmidt's family crest.

Production at Centennial Brewing skyrocketed after Schmidt left, jumping to forty thousand barrels of beer annually and using five million pounds of Montana barley and eighty-five thousand pounds of hops to do it.

The owners claimed in advertisements it was the "largest brewing plant west of St. Paul and north of Sacramento."

Butte's other breweries were on their way up too. By 1885, Butte's Silver Bow Brewery was producing four thousand barrels of porters and pale lagers annually, and the Butte Brewing Company produced over eighteen thousand barrels annually by 1900. It also built its own malt house capable of handling ten thousand pounds of malt per day.

It was around this time that the Centennial Brewing Company added its own Olympia Brewing to its brewery portfolio, but this one was based in Butte instead of Washington.

The Butte version of Olympia Brewing operated from 1899 until 1911, when the company was folded back into Centennial Brewing. During its reign, however, it released an Olympia Exquisite Brew that described itself as an "Andechser Lager," referring to the style of lager made at Kloster Andechs, a 1455 monastery southwest of Munich, Germany.

When Prohibition struck on January 1, 1919 and closed down all of Butte's brewing activities, it was only the Butte Brewing Company that later reopened. Montana enacted its Prohibition one year and fifteen days earlier than the national Prohibition. And just prior to that, the Butte Brewery heavily promoted its Eureka Beer as "liquid food for temperate people." During Prohibition, the brewery stayed alive by marketing malted soft drinks and other beverages under the Checo brand. When the brewery reopened, it was able to continue producing beer until Butte's disastrous

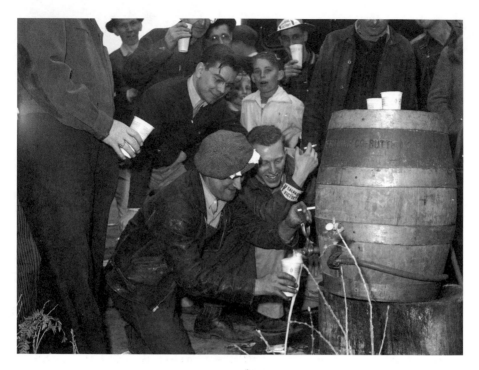

Butte citizens enjoy a keg of beer in October 1942. *Courtesy of Library of Congress.*

economic downtown in the 1960s, and the brewery closed down in 1963. Butte did not have a brewery again until Quarry Brewing opened in 2007. The name and brand, Butte Brewing, is expected to get its third breath of life in 2013, when Tony Olson and Mike Howard open their brewery at 465 East Galena Street.

LONG LIVE THE BEER

The Kessler Brewing Company, located just west of today's Spring Meadow Lake in Helena, operated from 1865 to 1958, making it one of Montana's longest-running breweries. What would become the Kessler Brewing Company was started by Charles Beeher, the same man who started Montana's first brewery in Virginia City before selling it to H.S. Gilbert. Beeher founded the brewery in 1865, and three years later, just as he had been in Virginia City, he was bought out, this time by Luxembourg-born

Nickolas Kessler, an entrepreneur who dabbled in everything from gold prospecting to trade and manufacturing.

Right after purchasing the brewery, Nickolas started a nearby brickyard in order to help build the city of Helena. That brickyard would later be the basis for the Archie Bray Foundation for the Ceramic Arts.

In 1891, Nickolas's son, Charles Kessler, began working at the brewery. Charles went off to Chicago to study at the Wahl-Henius Institute, a school pioneering in scientific brewing methods. After he graduated in 1895, he came back to work until the company incorporated in 1901 and Charles became president of the brewery.

As president, Charles was responsible for fighting the growing Prohibition movement and facing stiff competition by Eastern brewers made possible by marketing bottled beers and developing interstate transportation networks. To address these concerns, he founded the Montana State Brewers Association in April 1902, making the organization an associate member of the United States Brewers Association.

Charles, however, could not stop Prohibition. On June 28, 1919, the U.S. Collector of Internal Revenue certified the destruction of 588 gallons of Kessler beer, and then Kessler Brewing Company was closed until the repeal in 1933. After reincorporating, Frederick Kessler became president of the brewery until his death in 1949. His son-in-law, Marc M. Buterbaugh, succeeded Charles and ran the company until it closed due to lack of business in 1953. In its last year of operation, though it had the capacity to brew forty thousand barrels, the brewery only sold four thousand.

In 1984, the name Kessler Beer was revived by the Montana Beverages, Ltd. However, it was not tied to the Kessler family or the original brewery. The new Kessler Brewery brewed in downtown Helena until 2000.

THE SELECT

Montana's "last best brewery" is arguably Great Falls Breweries, Inc. As it closed its doors in Montana in 1968, it was the last operational brewery inside the 400,000 square miles of Montana, Idaho, Wyoming and North Dakota. Prior to that, however, the brewery enjoyed decades of success and had a history stretching back to 1893.

The brewery began as the Montana Brewing Company in 1893. Its flagship beer at the time was Silver Spray. Technically, it was the second brewery in the

Electric City, as the Volk Brewery, started by Christian Sr. and Nicholas Volk, opened in 1888 on Upper River Road. That brewery was built from native stone and wood. Its beers were delivered to the Great Falls area and the Sun River Valley. However, it burned down in 1894, leaving only its stone foundation.

The Montana Brewing Company built its massive complex on the west end of First Avenue North, right on the banks of the Missouri River. The year that the Volk Brewery burned, the Montana Brewing Company released advertisements that read, "We guarantee our Beers to be Strictly Pure, Brewed from the Choicest Brands of Imported Hops and Montana Malt…All orders for keg or bottle beer promptly attended to and delivered to any part of the city."

As Prohibition approached, the Montana Brewing Company became the American Brewing Company, and the company released a couple more choice advertisements. One read:

> *WOMAN OF THE HOUSE: Upon her often falls a heavy burden, the daily routine of housework, the care of children, the shopping, the social duties. Small wonder that she often sustains a "breakdown" and must receive medical assistance. Such a result may be avoided by moderate use of AMERICAN BEER.*

Another American Brewing ad promised men that a "tete-a-tete" with a woman will go much better if they are both drinking the American brand of beer because it "furnishes animation, sharpens the wit and makes conversation flow."

Once Prohibition went into effect, however, both the American brand and questionable advertisements were no more. In 1933, when brewing was legal again, Emil Sick stepped in and bought interest in the former brewery and launched Great Falls Breweries, Inc. His signature beer was Bohemian Style Lager, which he quickly changed to Great Falls Select because of pressures in Europe. At this time, Hitler was coming into power in Europe and breweries in the United States were asked to divest themselves of anything with a German tone.

With Great Falls Select in place, Sick ran the brewery until he sold to local interests in 1949. The new owners kept brewing Great Falls Select because, even though it suffered a poor reputation at times, it was still one of the most famous Montana beers of the twentieth century.

However, the new owners did introduce three other beers, including Big Sky Beer, Frontier Town Beer and Western Beer. In 1966, the owners sold their interest to the Blitz-Weinhard Brewing Company based in Portland,

Oregon. Blitz-Weinhard brewed Great Falls Select in Great Falls for two more years until it shut down the brewery and moved production of the beer to its brewery in Oregon. The brand was produced until around 1980, when Blitz-Weinhard cited a lack of funds to properly promote the beer and retired it.

The Great Falls Select trademark was picked up by Harvest Moon Brewing Company in Belt, Montana, in 2008, and the brewery has since re-released its own canned version of the beer. The most obvious and notable difference is that the new beer is an ale, whereas the traditional recipe was a light lager.

BEER IN THE MIDDLE OF EVERYWHERE

Lewistown, Montana, sits in the exact center of the state of Montana. The town is one hundred miles east of Great Falls and was founded in 1883. Eleven years later, it had its own brewery. The Lewistown Brewing Company could exist because it was positioned right in the middle of Montana's booming agricultural epicenter. The town had its own mill to grind wheat into flour, and then it had a brewery to turn barley into beer.

The founders of Lewistown Brewing Company were Frank Haas and Philip Laux. They bought a piece of land one mile south of town on the banks of Spring Creek. The two-story structure was built entirely of locally quarried sandstone. At capacity, the brewery could produce ten barrels per day.

After two years, the owners found it difficult to compete with national beers, so they sold the business to Bernard McDonnell, who ran it for eight years. He was a careful and conservative businessman, but one who knew the power of branding a local product. In an ad he wrote for the March 13, 1900 edition of the *Lewistown Eagle*, McDonnell cited "Pure, Wholesome Beer! It is Chemically Pure and is recommended by Physicians for its Splendid Medicinal Properties."

In 1904, he sold his shares to a new investor, and that investor sold off in 1912 to Gus Hodel, the former brewmaster and superintendent of the Centennial Brewing Company in Butte. Hodel steered the brewery toward great success until it was forced to close for Prohibition.

While most breweries followed the law and turned to producing soft drinks during the ban on alcohol sales, Hodel gambled that his brewery's remote nature and some bribery would allow him to produce a little more than "near-beer." In 1922, a former prohibition enforcement director, O.H. Shelly, was indicted on twelve counts of accepting bribes. Among those he

had received money from were the Montana Brewing Company of Great Falls and the Lewistown Brewing Company.

With all the attention from his actions, Hodel fled north into Canada. On the night before Canada repealed its prohibition law on January 1, 1924, Hodel crossed the border and headed to Medicine Hat, Alberta, with $2,000 in his pocket (earned by selling his Lewistown home). With a few investors, he reopened the ten-year-old Medicine Hat Brewing Company.

Two years later, when Montana repealed its statewide "dry" laws, leaving Prohibition enforcement up to federal agents, Hodel thought he could come home and make beer again without interference. He was wrong. On September 19, 1928, the brewery was raided and Hodel, along with one other employee, was arrested. Federal agents destroyed eight hundred quarts of beer and dumped six hundred gallons from the brewery tanks. They also confiscated all Hodel's brewing equipment.

Hodel's employee received a sixty-day jail sentence, but Hodel fled to Canada before his trial, though he made good on his $300 bond first. He returned about a year later, and the government did not seem concerned about his past, likely because he had paid his bond. For another year he brewed root beer, but when the stock market crashed, he once again returned to Canada.

This time he brewed for the Wentzler's Star Brewing Company in North Battleford, Saskatchewan. However, when the United States finally passed the repeal, Hodel came back home and reopened the Lewistown Brewing Company.

To mark the brewery's return, Hodel ran an ad in the local paper that read, "A Renewal of An Old Industry in the City. Lewistown Beer is meeting the approval of Montana's most discriminating palates…its [sic] a high grade, smooth beer, brewed from the finest materials by 'old masters' who know the business." Near the bottom of the ad, in the smallest typeset, was the brewery's new slogan, "Better than it used to be—and it used to be the best."

Soon the brewery was producing twenty-five barrels a day, and each barrel was made from wood lined with pitch and contained thirty-two gallons. The new flagship beer was called Silvertip, which on its label was described as "Healthful, Refreshing, Nutritious, Fully Matured and Aged."

Although it tried hard to re-establish itself, the Lewistown Brewing Company could not compete with national breweries. And as if its coffin needed a final nail, the Brewers' Union in Great Falls began demanding that the brewery increase its wages to employees, which it could not afford. Instead, Hodel sold off the brass, copper and other metals in his equipment, as it was needed for World War II, and the business closed its door for good in 1938.

It is not known if Hodel then fled back to Canada.

Today the original brewery building remains partially intact (though not enough to make it eligible for recognition as a historical structure), and it serves as the Snowy Mountain Honey Ranch.

The Beer that Made Milwaukee Jealous

The Magic City of Billings will always be remembered in the annals of beer history for making "the beer that made Milwaukee jealous." The slogan was coined by the Billings Brewery, which opened in 1900 between First Avenue North and Montana Avenue, and it was used for its flagship, Old Fashion Beer. The Billings Brewery was an offshoot of Centennial Brewing in Butte because the founders of the Butte brewery wanted to expand into the Billings market, so they created a new brewery.

The brewery promoted its flagship beer before it was even made, and when the first batch was ready more than three thousand people showed up to try it. Billings Brewery president, Phil Grein, understood immediately the power of marketing and controlling a market.

In 1910, he built a large beer bottle car (one that resembled a "weinermobile") that promoted Old Fashion Beer, and he drove it around town, at special events and during every parade in and around Billings. (Unfortunately, the car was eventually scrapped for metal.)

The Billings Brewery also invested in one of the largest electric signs in that day. The company erected a forty- by twenty-five-foot electric sign to the top of its three-story building, fitted with 920 electric bulbs that flashed in sequence and made the sign look as if beer was pouring from a bottle into a glass. People came from all over just to see the sign in action. It was visible nearly all the way down Montana Avenue.

So the Billings Brewery had people's attention; now it just needed their business, as the brewery was capable of producing two hundred thousand barrels of Old Fashion a year. In order to drive business, Grein simply created it, and the Billings Brewery began leasing lots it owned to those who promised to open a saloon. And the most prominent beer served at those saloons would be none other than Old Fashion.

By 1907, the Billings Brewery "scheme" resulted in the town having forty-two saloons and only a population of eight thousand to support them.

But business grew as Prohibition loomed. In 1916, the brewery turned a profit of $57,000, marking its best year, but when everything shut down

in 1919, Billings Brewery was forced to dump $11,876 worth of its beer into the sewer.

By the time the Repeal was in place, the brewery's momentum was lost. The state made a new law that forbid a brewery to own a bar, which had been its cash crop. (Interestingly, it is this same law that was repealed in 1999 that allowed breweries to start selling pints in their taprooms.) Beer was also heavily taxed. The state of Montana collected eighty-six cents per keg, and the federal government collected six cents a gallon.

To add insult to injury, technologies like refrigeration, pasteurization and the development of lightweight cans made it much easier for large national breweries to move into and dominate new markets, which they did all over Montana.

By the end of World War II, the Billings Brewery equipment was in serious need of repair due to severe deterioration over the years. The owners tried to re-varnish the tanks but did not wait long enough for the varnish to dry before making another batch. The result was not good. Their entire filtering system was off, and they were finding all types of contaminants in the finished product.

In 1950, the brewery dumped almost six thousand gallons of beer because of "foreign matter." In its attempt to breathe new life into the brand, the company changed its iconic red label to a green one and changed its flat-topped cans to a cone-top style. Customers quickly labeled the beer, "Green Death."

In another attempt to save face, Francis B. "Red" Welsh was put in charge of the brewery in 1951, and he chose to abandon Old Fashion altogether and release a new light beer called simply Tap Beer.

It didn't work. By December 1951, the stockholders of Billings Brewery voted to close up shop, and it is rumored that Milwaukee was no longer jealous.

BEER AND BASEBALL

While most of Montana's notable historic breweries were east of the Continental Divide, Missoula was home to a local favorite that enjoyed a relatively long life. The beer was called Highlander, and it is still being made today (contract brewed as a Red Ale at Great Northern Brewing Company in Whitefish).

Highlander beer got its humble start at the Garden City Brewing Company, which opened in 1895 at the base of Waterworks Hill in Missoula's Rattlesnake Valley, just north of the Clark Fork River. Unfortunately, the site of the original brewery is now covered by Interstate 90.

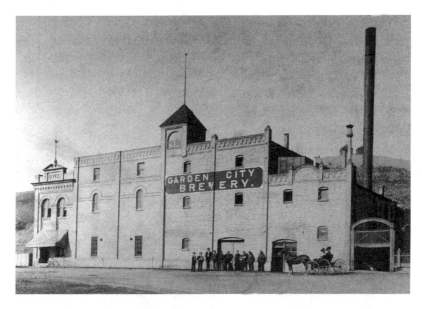

Exterior of the Garden City Brewery, Missoula, Montana. (Taken between 1895 and 1905.) *Courtesy of The HMFM Irene Dolan Collection 1979.32.1. Used by Permission. All Rights Reserved.*

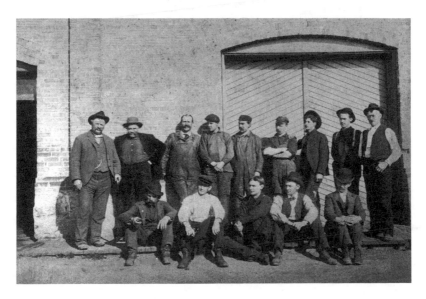

"Garden City Brewing Company, Missoula MT" Joe Steiger (back row, left), Henry Emmerich (back row, sixth from left) and Joe Riddle (back row, right). *Courtesy of the HMFM Irene Dolan Collection 1979.32.2. Used by Permission. All Rights Reserved.*

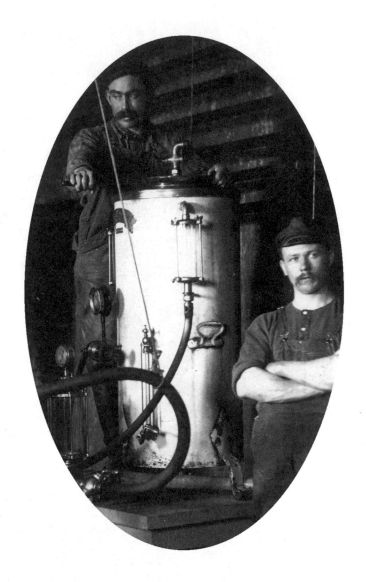

"Henry Emmerich inside the Garden City Brewery, Missoula MT." *Courtesy of the HMFM Irene Dolan Collection 1979.32.3. Used by Permission. All Rights Reserved.*

Opposite, top: "The Louvre Salon inside the Florence Hotel." At right is Henry Emmerick. *Courtesy of the HMFM Irene Dolan Collection 1979.32.7. Used by Permission. All Rights Reserved.*

Opposite, bottom: "The 4 Mile Exchange, Owned by Henry Emmerich" In the early twentieth century, a glass of beer cost a nickel at the 4 Mile Exchange in Cold Springs, Missoula. *Courtesy of the HMFM Irene Dolan Collection 1979.32.9. Used by Permission. All Rights Reserved.*

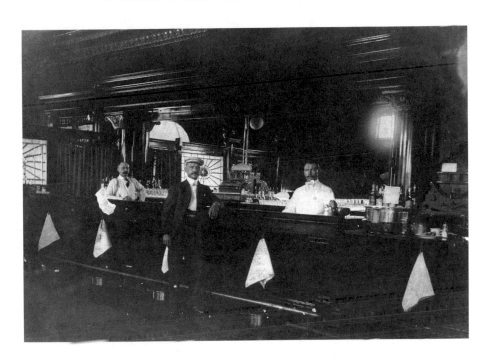

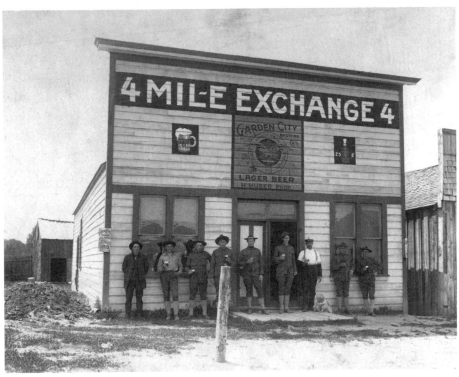

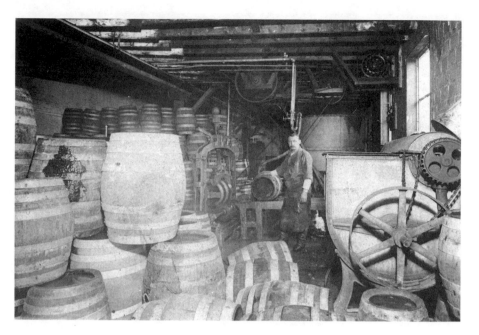

"Interior of the Garden City Brewery, Missoula MT." *Courtesy of the HMFM Irene Dolan Collection 1979.32.20). Used by Permission. All Rights Reserved.*

Without an easy and reliable transportation network in place to other communities, the Garden City Brewing Company focused on making beer for its own community. In 1910, Highlander Beer debuted, but for the launch of the new beer the brewery owners needed to get permission from the entity that owned the title, "Highlander." That entity was a little-known baseball team in New York City called the New York Highlanders. The owners of the brewery wrote a letter to the owner of the baseball team asking for consent to use the name.

The baseball team owner wrote back and said, "Sure, go ahead, because we are going to change our name soon anyway." By the end of the 1912 season, the New York Highlanders became the New York Yankees.

It enjoyed modest success up until Prohibition. The owners of the brewery tried hard to sell the brewery in 1922, but no one was in the market for a business that couldn't operate. The owners scraped by selling near beer and nonalcoholic beverages until they were finally able to sell the brewery in 1934.

The new owners named the brewery the Missoula Brewing Company. Again Highlander was the signature beer, which at the time was a western-

style lager patterned after the most popular beer of the day, Olympia. But again the brewery changed hands in 1944. The man who bought the business was Emil Sick, the then-current owner of Great Falls Breweries, Inc. (makers of Great Falls Select). Unlike his Great Falls brewery, which he sold in 1949, Sick hung onto the Highlander brand and brewery until the 1960s. During the 1950s the brewery adopted the classic Scottish tartan look for which the brand is still known today.

As the economic slump of the 1960s hit Montana, and everywhere else, the small brewery could not withstand national competition. Sick sold off many of his brands and closed up the Missoula Brewing Company. It is likely that Sick took a government buy-out then because the brewery's closing coincided with the arrival of Interstate 90. The building was razed in 1964, three years before Great Falls Breweries, Inc. was shut down.

GOT GRAIN?

In 2013, Montana overtook its eastern neighbor, North Dakota, to become the top barley-producing state in the country, planting 1,000,000 acres of barley against North Dakota's 950,000, something that rarely happens, according to the Montana Grain Growers Association. The third-place state for barley is Idaho, planting 620,000 acres. For national perspective, Montana is growing nearly a third of the country's total yield.

Montana's primary crop is still wheat, planting 5.5 million acres in 2013, but that number is down this year because more farmers are growing barley instead.

"We have some of the best barley in the word," Steve Becker, outreach coordinator for Montana Wheat and Barley Committee, recently told a Great Falls newspaper. "That is why most all of our barley is contracted out by major barley companies."

In Montana, barley is grown in every county except for Lincoln and Mineral Counties. Barley is especially well suited for the region's cool climate. Only the highest-quality barley can be used for malting. Lesser qualities are used for cereals and other food products.

Barley was one of the first grains grown in many countries, including China, Nepal, Tibet and Ethiopia. It has been cultivated for at least five thousand years. The Hebrews made the grain the symbol of power and gave it a warlike connotation, which was also shared by the Romans and the Vikings.

Montana Z Broken O Ranch barley field. *Courtesy of Malteurop North America Inc.*

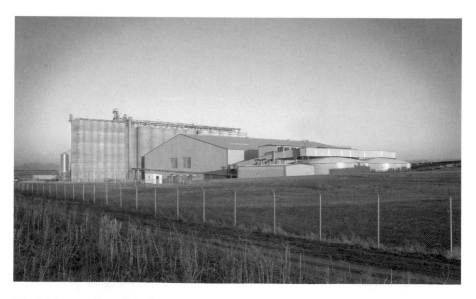

The Malteurop Great Falls facility, which processes 260,000 tons of barley annually. *Courtesy of Malteurop North America Inc.*

The grain came to America with Christopher Columbus in 1493. There are sixteen different species of known barley. Common barley (*Hordeum vulgare*) is a cereal grain produced on a large scale and accounts for 8 percent of the world cereal production, behind corn, rice and wheat. There are two common types of barley, winter and spring, but both are equally acceptable for malting for beer production.

In 2013, Montana-grown malt barley is fetching an average of $5.49 per bushel, with feed barley fetching $4.69 per bushel.

The "cream of the barley crop" comes from Fairfield, in north central Montana (population 708). It has earned the title of "Malting Barley Capital of the World," which is why Anheuser-Busch and MillerCoors are the top barley purchasers there.

A second-generation barley grower, Brian Beerman, plants 535 acres of barley on his family land, and he has done so for the past forty-three years. Half of what he grows is proprietary barley contracted with MillerCoors, and the other half is also proprietary and goes to Anheuser-Busch. His yield for each company will be around twenty-five thousand bushels. There is roughly forty-eight pounds to a bushel of barley.

"I grow on the Fairfield Bench," says Beerman, "which plants around 88,000 acres. Barley grows great up here because we have the perfect weather and soil for it, and I've not seen barley prices this high in a long time."

Most of the grain gets taken to one of the corporate brewing company's designated grain elevators, where it gets picked up and taken to a malting facility.

Some barley growers in Montana, however, can take their crops to Great Falls, where Malteurop operates its newest and largest-producing U.S. malting facility. Malteurop is the largest maltster in the world. Commissioned in 2006, the state-of-the-art malting facility in Great Falls processes 260,000 tons of barley each year, with most of that grown in Montana. The Great Falls facility only produces a Pilsen malt. Since there is no roasting capability there, the facility cannot produce specialty roasted malts, such as chocolate or black malt.

Pilsen malt is a typical base malt, often accounting for up to 75 percent of the total grain bill in a beer recipe and can be used in a very wide variety of beer styles.

"We love the Montana brewing community," says Amy Germershausen, account manager for Malteurop North America, Inc. "It has a great closed supply chain. You have excellent barley, a top malting facility and terrific water. So many Montana brewers are producing excellent beer. We service a lot of the breweries in the state, but not all of them. Our overall customer

size ranges from brewers producing 700 barrels a year to 100 million barrels. We like having that diversity in our supply. The local brewers bring a lot to our table."

Great Falls makes an ideal location for a malting facility because of its access to grain grower; that's a given. However, it is what is underground that is as important as what it growing above ground that makes Great Falls perfect.

"We chose Great Falls because, in addition to the grain, the water we get from Giant Springs stays a constant temperature year-round," says Germershausen. "And we don't need to treat it. When you're dealing with a living organism on a large scale, as we are, consistency is very important, and it helps when the water stays consistent for us."

In order to convert barley into malt, a reaction must cause the grain to germinate and set in motion a transformation that usually happens naturally to the plant during a normal growth cycle, and then the transformation must be halted, fairly quickly, in order to achieve desired characteristics.

The total transformation time of barley into malt takes about eight days and can be broken down into four main stages.

The first step is steeping. This is the stage in which the barley grain is prepared for germination by introducing moisture. Its moisture content is increased from 15 percent to 45 percent, at which point the grain is fully ready to germinate.

The two principles employed here are steeping through immersion and steeping through aspersion. With immersion, the grain is literally immersed in water, alternating with draining and exposing to dry air. During this phase, the grain is rotated and oxygenated using compressed air. When it is drained, the air is renewed frequently to eliminate the CO_2 and heat that is produced and to provide it with the fresh oxygen it needs.

When aspersion is used, a combination of abundant spraying and ample air renewal is used to humidify the grain. The total process takes between thirty to forty-five hours, and at the end of this stage, the germ and the developing roots, known as rootlets, appear.

In the second stage, called germination, the germ that was activated during steeping is allowed to develop and go through major internal biochemical changes. The grain's embryo will conduct a liberation and activation of a multitude of enzymes that will give the final malt a large part of its richness.

The layer of grain is spread on a perforated grain floor and constantly ventilated with air whose temperature and humidity are controlled in order for the grain to respire, which is indispensable for the grain at this stage. After

spending three to six days in this state, during which the grain is routinely turned and sometimes watered, the gemmule becomes as large as the grain itself, and the rootlets that have grown look weathered. At this point, the malt is referred to as green malt.

The third stage is kilning. Too often this step is thought of as simply drying out the sprouted grain. What really happens is multiple transformations that make it a true organoleptic and enzymatic refining process, also indispensible to the quality of the finished malt. At first, the biochemical reactions accelerate under the effect of increasing temperature, but the decreasing humidity gradually halts all enzymatic activity. When the humidity is low enough, the temperature is rapidly raised to eighty-five degrees Celsius (for Pilsen malt) during a curing period of a few hours. The purpose is to eliminate molecules that can cause unwanted tastes or bring out undesired aromatic compounds. Following a final cooling, the malt leaves the kiln with a humidity level of 4.0 to 4.5 percent, which will allow it to be stored for several months.

In the final stage of the malting process, known as deculming, the rootlets that formed during germination are removed by passing the grain over vibrating screens. Since the grains are very dry, the rootlets fall away easily. The high protein content of this "culm" makes it a desirable ingredient for animal feed.

When the malt leaves the malting plant, it is in the form of a dry and brittle golden-yellow meal. The product is shipped in bulk, and its shelf life can extend to up to a year under strictly controlled conditions.

Now all that is really left to do is mash, sparge and boil the malt and hops and then pitch yeast. That is how a Montana beer is born.

CHAPTER 2
GLACIER COUNTRY

DESERT MOUNTAIN BREWING AND DRAUGHTHAUS

729 NUCLEUS AVENUE
WWW.DESERTMOUNTAINBREWING.COM
COLUMBIA FALLS (POPULATION 4,707)
406-892-2739 (BREW)
SIGNATURE BEERS: TWO OCEAN IPA, SIYEH STOUT, BAD MARRIAGE BLONDE,
 GUNSIGHT PALE ALE
NOON TO 8:00 P.M. MONDAY–SATURDAY. NOON TO 6:00 P.M. SUNDAY

Montana's newest brewery is also the state's smallest. Shawn and Kelley Christensen opened Desert Mountain Brewing and Draughthaus on March 6, 2013 (four days after Bridger Brewing opened in Bozeman). Located in the new Cosley building in downtown Columbia Falls, Desert Mountain Brewing is officially the closest brewery to Glacier National Park, which attracts up to 1.9 million visitors every year.

The couple had a son, Jonathan, while pursuing graduate studies in Bozeman, Montana. Realizing it was "now or never" for getting a career in place, they took their love for beer to the next level. They were already very familiar with the Columbia Falls area, with Kelley having served as editor for a couple local newspapers, *Hungry Horse News* and the *Daily Interlake*. It didn't take much discussion before they settled on the idea of a brewery and made it happen. In fact, start to finish, it only took fourteen months.

Right now, they brew two days a week on a four-barrel system. The brewery's target for 2013 is to hit four hundred barrels and be on tap at four or five area restaurants.

Each of the beers are named after famed places in Glacier National Park, and the brewery's name honors the large, flat-topped mountain visible through the gap between Teakettle Mountain and Columbia Mountain. Situated on the Flathead National Forest, Desert Mountain is a popular recreational area, especially for snowmobiling in the winter months.

Head brewer Shawn Christensen prides himself on not only making good beer but also making good beer that patrons would like to buy.

"Having the smallest brewing system in the state," say Shawn, "allows us to be nimble and appeal to everyone, especially the beer geeks."

Shawn will attempt to locally source as much of the adjuncts (fruits, spices, etc.) for the brewery's seasonals and one-offs as possible. He is committed to never using extracts in the brewing process.

The couple has already begun a "Dry Peak Mug Club" for its frequent visitors, giving each of the one hundred mug holders free beer three times a year on the day their number is drawn. They have also designated the thirteenth of every month as Flannel Day. By wearing flannel to the brewery that day, a patron receives fifty cents off the first pint. The last Sunday of every month is a "Stitch 'n B*tch" session, encouraging people to bring in their knitting or crochet projects to work on at the brewery.

Shawn and Kelley are also currently working with a local farmer to experiment with a one-acre hops farm and possibly growing their own barley.

GREAT NORTHERN BREWING COMPANY

2 Central Avenue

www.greatnorthernbrewing.com

Whitefish (population 6,384)

406-863-1000

Signature beers: Black Star Double Hopped Golden Lager, Wheatfish Ale, Wild Huckleberry Wheat, Going to the Sun IPA, Good Medicine Imperial Ale

11:00 a.m. to 11:00 p.m. Monday–Sunday

Inside the tallest building in Whitefish are a lot of history and a lot of beer. Started in 1994 by Minott Wessinger, the great-great-grandson of Oregon brewing pioneer Henry Weinhard, the Great Northern Brewing Company was built in northwest Montana because of the exceptional water quality, the area's unique history and its active, outdoors-driven culture.

The brewery was named after two local icons, Great Northern Mountain and the Great Northern Railway Depot. Great Northern Mountain is the 8,705-foot peak seen from much of the Flathead Valley. The Great Northern Railway Depot is the busiest Amtrak stop between Seattle and Minneapolis.

In the mid-1990s, Minott Wessinger was looking to get back into the family business, having recalled many hours as a child playing in his father's brewery, the Blitz-Weinhard Brewery in Portland, Oregon. He toured all around Washington, Idaho, Oregon and Montana before he finally found and settled on Whitefish.

The brewery was designed by famed architect Joe Esherick, and as a sentimental touch, Minott brought over and installed a copper and brass hop-back that was once part of his grandfather's brewery. The hop-back is a device and vessel used to transfer back delicate hop oils and aromas that might otherwise be boiled off in the boiler. Once everything was in place, Minott began brewing his signature beer, the Black Star Double Hopped Golden Lager.

"Black Star beer is a good in-between beer," says Marcus Duffey, general manager of Great Northern Brewing. "Minott wanted to create a beer that had flavor and balance and one people could drink." For eight years, Great Northern Brewing produced Black Star. In 2003, Minott stopped production of the beer to pursue other projects, but in 2010 he re-launched the brand and made it even bigger. Through a partnership with MillerCoors, Black Star Beer became a national product, distributed throughout the country (though when it was first released in 1995, Black Star was distributed to metropolises like San Francisco and New York). All of the Black Star draught beer is still produced at the Great Northern Brewery, but everything in bottles or cans is contract brewed in Milwaukee. The recipe is the same Minott started with in 1995.

Beyond Black Star, Great Northern Brewing is also known for many other lagers and ales. In fact, one of the things that makes Great Northern stand out from other Montana breweries is the fact that it produces so many different lagers.

"To me there's a romance to the lager that has been lost," says Duffey, "because of the stereotype that just 'yellow beers' are lagers, which is not

Great Northern Brewing's mash tun sits at the top of the tallest building in Whitefish. *Courtesy of the author.*

true at all. There are many other classic styles of beers that are lagers. At the same time, we appreciate and love the qualities that come with ales. Doing both is really a lot of fun for us."

Wheatfish Ale, Wild Huckleberry Wheat and Going to the Sun IPA are all currently bottled and distributed from the brewery. Good Medicine Imperial Ale is next in line to be bottled.

Great Northern brews on a 20-barrel system and in 2012 produced 3,800 barrels. Though it has the capacity of brewing 8,000 barrels annually, its commitment to lagers slows the production calendar, making its true capacity between 5,000 and 6,000 barrels. In 2013, the brewery is on track to produce eighteen different beers, roughly ten of those lagers and eight ales.

Its brewing system is not common among other Montana commercial breweries, as it uses a "Gravity Flow" system, taking full advantage of being the tallest building in Whitefish.

As Minott and Esherick planned it, the building needed to be tall in order to house this system. Like the mountain streams that feed the valley's rivers below, this brewing concept is the same—start with mixing grain and water at the top and then let it "fall" down into the next vessel for hopping and boiling and yet again into the fermentation vessels. Many home brewers are familiar with this design, as the three-tiered systems most use are also gravity-flow, just on a much smaller scale.

Great Northern Brewing does another service for the Montana brewing culture at large. In 2008, Missoula's famed Highlander Beer was brought back to life after a forty-four-year hiatus, and chosen to contract brew this historic Scottish Red Ale was none other than Great Northern. Highlander is now available in both twenty-two-ounce bottles and on draught.

As a brewery with strong ties to the national beer scene via Black Star Beer, Great Northern Brewing is still very grounded in its Montana roots. It prides itself on taking care of its local customer base and being unique in its own ways.

"Montana is an island in terms of trends in the beer industry," says Duffey. "Some would say we lag behind, but I don't think so at all. I think the trends here are different, and we set our own pace and direction. People who come over from Oregon or Washington, sometimes they compare our beer culture to their beer culture, and they think they need to run along the same line. I think they can run parallel, but we are distinct and aren't looking to do what they are doing. We have different profiles, different water and different cultures."

Tours are given at the brewery during the summer Monday through Thursday at 1:00 and 3:00 p.m. All ages are welcome.

Tamarack Brewing Company

105 Blacktail Road, Suite #1
WWW.TAMARACKBREWING.COM
Lakeside (population 2,669)
406-844-0244
Signature beers: Hat Trick Hop IPA, Yard Sale Amber, Switchback Stout, Bear Bottom Blonde, Sip 'N Go Naked
11:00 a.m. to midnight Monday–Sunday

Looking to build a family business in Montana, Josh Townsley and his wife, Andra, left their home in Arizona to come to the western shores of Flathead Lake and open Tamarack Brewing Company in Lakeside in 2007. Josh was no stranger to beer. In Tempe, he helped found and run the Four Peaks Brewing Company, one of the state's largest brewpubs that produces nearly forty thousand barrels of beer a year.

After Josh and Andra had children, they decided they wanted a new place to raise their family, and they knew just the spot. Andra's family owned property along Flathead Lake, and often the couple would come to visit. Lakeside would be a perfect fit for their vision of a brewpub.

In July 2007, the doors opened. Josh brought a fellow Four Peaks brewer up to help get started, and on a ten-barrel system, they started brewing. Today, with their new brewer, Joe Byers, Tamarack Brewing serves up a dozen different beers on tap, a third of which rotate seasonally.

In 2012, the brewery produced 2,300 barrels, but by the end of 2013, that number will more than double to 4,800 barrels. This massive growth is due to the fact that in June 2013, Tamarack Brewing will increase its distribution to include a line of sixteen-ounce cans, sold as four-packs. Starting with its two flagship beers, Hat Trick Hop IPA and Yard Sale Amber, Tamarack beers will be available for the outdoor and backyard enthusiasts who enjoy the versatility of canned beer.

The Tamarack Brewing Company also serves up full lunch and dinner items with its beers, as the brewpub holds a liquor license so patrons can order food or mixed drinks, and the brewery can be open later than 8:00 p.m.

Through the years, Tamarack Brewing has served at least one hundred different beer styles and has a noted affinity for barrel-aging. Known as the "Monkey Barrel Series," Tamarack Brewing releases a variety of aged beers throughout the year, from sours to stouts, porters to IPAs.

"This is craft brewing," says Josh. "It's supposed to be fun. We are not a big production facility. We want to keep it fresh for our guests and our brewers."

In April 2011, Tamarack Brewing Company opened a brewpub in downtown Missoula. The full bar and restaurant features all of Tamarack Brewing's current beer selection (though it does not brew in Missoula). The idea to open a second location came to Josh essentially on a whim. He traveled to Missoula for a doctor's appointment and noticed a vacant building for sale downtown, the former Army Navy Supply Store. He called the number and saw the building that afternoon. It wasn't a fit for his needs, but the realtor said he had another location just down the street at 231 West Front, right beside the popular Caras Park and Clark Fork River. As soon as Josh walked in, he knew it was right.

"Missoula is a great town," says Josh. "It's full of educated beer drinkers."

Tamarack Brewing primarily distributes through its two brewpubs, with the exception of Hat Trick Hop IPA and Yard Sale Amber, which are also provided to select accounts in the Flathead Valley.

"As I learned with Four Peaks," says Josh, "your backyard is what you take care of, and I'm fortunate because I live in a beautiful place and I get to make beer." Josh credits the brewery's successes to the way the Lakeside and Missoula communities have embraced their business and their family.

Those in Lakeside, and beyond, know a lot about Andra's family. Her father is Lanny McDonald, a former professional ice hockey player who played for the Toronto Maple Leafs, Colorado Rockies and the Calgary Flames. He represented Team Canada on two occasions and won the inaugural Canada Cup in 1976. During his career, he played more than 1,100 games, scored five hundred goals and over one thousand points. As an inductee to the Hockey Hall of Fame (1992), Lanny is probably most well known for his 1989 game-six goal over the glove of Montreal Canadiens goaltender, Patrick Roy, to clinch the first Stanley Cup victory for the Calgary Flames.

"Lanny is a great man," says Josh, "and not just because he is my father-in-law. He represents hard work. That is why we created a tribute beer to him, because hard work is what we try to put into all our beers." The tribute beer is Old Stache Porter, honoring Lanny McDonald's iconic mustache "and the fact we stash the beer away for 180 days," says Josh. The barrel-aged porter is released every year on Lanny's birthday, February 16.

When Josh is not overseeing production at Tamarack Brewing Company, he serves as vice-president of the Montana Brewers Association (MBA). The MBA was created in 2008 for the purpose of promoting the production and sales of Montana-made beers. The organization is an outgrowth of the earlier Montana State Brewers Association, which was created in 1997. Currently, thirty of the state's breweries are members of the association.

"The MBA is about growing the Montana beer industry from the ground up," says Josh. "We strive to be a guide for local breweries and help them achieve their goals. If you have a dream, then you should have an opportunity. Isn't that what America is all about?"

FLATHEAD LAKE BREWING COMPANY

26008 E. LAKESHORE

WWW.FLATHEADLAKEBREWING.COM

BIGFORK (POPULATION 4,270)

406-837-0353

SIGNATURE BEERS: WILD MILE WHEAT, CENTENNIAL IPA, BUFFLEHEAD BROWN ALE,
 GALAXY PALE ALE, IMPERIAL IPA (IPA²), TWO RIVERS PALE ALE, 369' STOUT

3:00 TO 8:00 P.M. MONDAY–SUNDAY, EXCEPT NOON TO 8:00 P.M. ON SATURDAYS
 DURING SUMMER

Flathead Lake Brewing first opened in 2004. And as far as breweries in Montana go, it is a hard one to miss. Billed as "fresh brews with a view," it is situated idyllically on the eastern shores of Flathead Lake, which is the largest natural freshwater lake west of the Mississippi River. The brewery currently sits five miles south of Bigfork in the middle of Woods Bay. However, by the end of 2013 the brewery plans to move its brewing production into an old bowling alley in the heart of Bigfork and build a new restaurant there as well, but that project is still underway.

The brewery was under joint ownership from 2004 until July 2009, when co-owner Greg Johnston split with his partner and became the sole proprietor. Johnston worked diligently to reopen the brewery in March 2010, rehiring Tim Jacoby as head brewer, who had been with Flathead Lake Brewing since 2007.

"I always wanted to have a business on the water in Montana," says Johnston. "There's a uniqueness to the Montana lifestyle and friendliness of the people here that you can't find anywhere else. Plus we have fantastic water that makes great beer." The water the brewery uses is pulled from an artesian aquifer that is replenished by glacial melt.

Jacoby brews beers on a fifteen-barrel system, one Johnston bought from a restaurant in Ohio. Once the brewery moves into its new location, it will upgrade to a thirty-barrel brewhouse, allowing Jacoby to "play" with a variety of batches, styles and seasonals.

Currently, the brewery produces at least ten different styles each year, including Belgian styles like its Swimmer's Itch Saison and Dirty Ginger Belgian Strong Ale. In 2012, the brewery produced one thousand barrels of beer.

Flathead Lake Brewing packages several of its flagship beer in twenty-two-ounce "bombers" for distribution throughout western

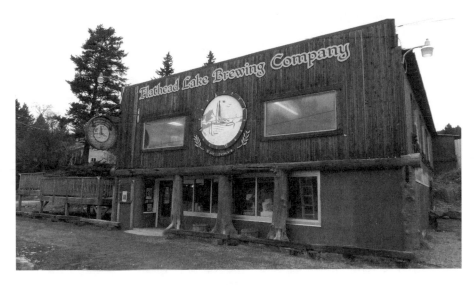

Flathead Lake Brewing Company in Woods Bay. This brewery location is expected to remain open after its relocation and expansion into Bigfork. *Courtesy of Flathead Lake Brewing Company*.

Montana. Once it can fully meet all the demand for its beers, it will look to move into the eastern Montana market. The brewery does plan to start canning at its new location, having the ability to produce both twelve-ounce and sixteen-ounce cans to distribute along with its twenty-two-ounce bottles.

Also noteworthy about the pending move is that the new location will be LEED certified, with hopes of becoming the second GOLD LEED production brewery in the United States. The other is Mother Earth Brewing in Kinston, North Carolina.

The brewery also operates a brewpub in Missoula called Flathead Lake Brewing Company of Missoula (424 North Higgins), where no beer is brewed but all the brewery's beers are available for pints and growler fills.

The Flathead Lake Brewing Company is also one of only two breweries in the state that contracts with Carlburg Pottery in Kalispell for its custom ceramic growlers.

GLACIER BREWING COMPANY

6 TENTH AVENUE EAST
WWW.GLACIERBREWING.COM
POLSON (POPULATION 4,524)
406-883-2595
SIGNATURE BEERS: GOLDEN GRIZZLY ALE, SLURRY BOMBER STOUT, WILDHORSE
ISLAND PALE ALE, FLATHEAD CHERRY ALE
4:00 P.M. TO 8:00 P.M. TUESDAY–SATURDAY

Glacier Brewing Company is about as idyllically set as a brewery in Montana gets. With its swinging, saloon-style doors and iconic wooden sign above the entrance that reads "BREWERY," (inspired by the H.S. Gilbert Brewery in Virginia City, Montana—the state's first brewery built in 1863), and the fact the town of Polson sits at the foot of the stunning Flathead Lake, the largest natural freshwater lake west of the Mississippi River, makes the brewery a hub of history and a scenic destination. The bar is covered with beer labels from former Montana breweries. The walls are adorned with vintage regional breweriana, and brewery founder, Dave Ayers, is the man inside who can tell patrons about all of them.

Ayers opened the Glacier Brewing Company in 2003. Before moving to Montana to open it, however, he and his girlfriend (now wife) lived in Colorado. For several summers, the couple took road trips through Montana because Ayers's girlfriend worked seasonally for Glacier National Park. During their trip in 1993, Ayers got the idea, quite suddenly, for a brewery.

"The idea hit me with such a force that it consumed my thoughts for a hundred miles," says Ayers, "I had the brewery name picked out. I also had the beer names picked out, and I drew sketches of what everything would look like. Originally, though, I thought I would open in West Glacier."

However, Ayers did not yet move to Montana. It would take a little longer. While in Colorado, he worked as the award-winning head brewer for the H.C. Berger Brewery in Fort Collins (now Fort Collins Brewery). After he left, he did a little residential and commercial remodeling work before being offered another brewing job in Telluride, which he took. During lunch one day, he was with his wife and brother-in-law, who was about to move to Montana. As if the spark fired again in his mind, the three decided they would all move to Montana and open a brewery.

Ayers found a used brewing system in California before he even had a brewery, so he brought the equipment to his father-in-law's Christmas

Left: The idea to open a brewery in Montana hit Dave Ayers suddenly during a road trip. He quickly sketched ideas for his future brewery. *Courtesy of Glacier Brewing Company*.

Below: Glacier Brewing Company self-distributed to accounts during its first year in business. Then brewer Dave Ayers thought Montana was too big to do it alone, so he signed with a distributor. *Courtesy of Glacier Brewing Company*.

Glacier Brewing Company makes eight hundred barrels of beer annually, with 40 percent of production being bottled. *Courtesy of Glacier Brewing Company.*

tree farm outside Polson, where it would sit nearly a year until he built his brewery.

They finally found the right building, an old racquetball court on Tenth Avenue, "which makes an ideal brewing space," says Ayers.

After opening, Ayers began brewing and distributing his beers throughout western Montana, filling kegs and bottling six-packs. He self-distributed for the first year but found out quickly that Montana is a big state. Some of his original beers are still his signature ones, such as Golden Grizzly Ale and Slurry Bomber Stout. It took a while before he caved to make an IPA, which happens to now be Glacier Brewing's top seller.

"We don't follow trends," says Ayers. "I believe in our beers, and being small we can change and try new things whenever we want."

Though still bound to the seasonal nature of Montana tourism, the Glacier Brewing taproom is well supported by the local residents, even being referred to as the "unofficial Chamber of Commerce for Polson." From birthdays to business meetings, the townspeople and others living on the

Flathead Indian Reservation come to the brewery to share their stories and keep each other company.

Ayers brews about eight hundred barrels annually on his ten-barrel system, with about 40 percent being bottled. Over the decade he has been open, he has created over two dozen different beers. And though he has plans to expand into new markets throughout the state, he wants to take it slow.

"You know growth for growth's sake is a cancer cell," Ayers remarks.

For now, Ayers is staying focused on keeping his two main markets, Polson and Missoula, supplied with beer, and while he does so he never forgets what is special about owning a brewery in Montana.

"When I brew," says Ayers, "I feel like I'm standing on the shoulders of the giants who came before me. Montana has one of the deepest beer histories in the country." And for the patrons who visit his taproom, they can see firsthand those giants' proverbial footsteps.

BAYERN BREWING

1507 MONTANA STREET
WWW.BAYERNBREWERY.COM
MISSOULA (POPULATION 67,290)
406-721-1482
SIGNATURE BEERS: BAYERN AMBER, BAYERN PILSENER, DANCING TROUT
NOON TO 8:00 P.M. MONDAY–SUNDAY

Bayern Brewing can easily be described as one of Montana's founding pillars of the state's current microbrewery movement. Open since 1987, it holds many honors: serving as the state's only German microbrewery, the oldest brewery in Montana still in operation and the first to open in Missoula since the Missoula Brewing Company (original makers of Highlander Beer) closed its doors in 1964.

At the helm of Bayern Brewing is the ever enthusiastic and authentic Jürgen Knöller. Born and raised in Bavaria, Germany, a mere forty kilometers from the Neuschwanstein Castle in Füssen, Knöller was handpicked to be the brewmaster as soon as he graduated from Doemens' Masterschool for Brewing and Soft Drink Technology in Munich. He literally arrived in Missoula the day Bayern opened for business—August, 6, 1987—carrying two suitcases, one with clothes and the other filled with brewing books.

Bayern Brewing is the oldest brewery still in operation in Montana. It was founded in 1987. *Courtesy of Bayern Brewing.*

Bayern prides itself on the fact that its beers are brewed in strict accordance with the *Reinheitsgebot*, or German Beer Purity Law. Like Knöller himself, this law originated in Bavaria. It dates back to 1516 and mandates that the only ingredients that can be used in the production of beer are water, barley and hops. To achieve this in the strictest sense at Bayern, every piece of equipment and every recipe is German.

In 1991, four years after moving to Missoula, Knöller bought the brewery from its original owner and has been in charge of operations ever since. Soon after taking command, he brought back the notion of beer bottling to Missoula, beginning with Bayern's own first beer, Bayern Amber.

In 2001, he hired Thorsten Geuer as the new brewmaster. Geuer, having served his three-year apprenticeship at the Hofbräu Früh brewery in Cologne, Germany, which is reportedly the first brewery to have brewed

Thorsten Geuer (left) and Jürgen Knöller (right) always wear the proper attire when pouring Bayern beers at the Garden City Brewfest in Missoula. *Courtesy of Justin Lee.*

Kölsch beer, first visited Bayern Brewing during a summer internship at the brewery in 1999. After the internship, he went back to the famous brewing college, VLB Berlin, graduated and came back to Missoula immediately to begin work as the new *braumeister*.

"I've always liked brewing," says Geuer, "because at the end of the week you have a product in your hand. You turn water, grain and hops into a product that usually is appreciated by people, and I like that."

Originally housed at the north end of Higgins Avenue in the historic Northern Pacific Railroad Depot (built in 1901) as part of the Iron Horse Brewpub, Bayern Brewery now produces ten thousand barrels annually from a multi-million dollar facility Knöller opened in 2002.

Bayern was the first brewery after Big Sky Brewing (also in Missoula) to hit the state's ten-thousand-barrel limit, technically making it the second-largest brewery in the state, though a few others are also brewing at that limit. If needed, Bayern can expand its current brewery operation to produce up to one hundred thousand barrels per year.

In addition to Bayern's mainstays—Bayern Amber, Bayern Pilsener and Dancing Trout—the brewery churns out one of its many popular seasonal beers on a very strict schedule: one every ten weeks. Its seasonals account for roughly 40 percent of total beer sales, and all but two of its beers are bottled.

Bayern beer, undoubtedly, is a longtime Missoula favorite, as 50 percent (or five thousand barrels annually) of all the beer the brewery produces is consumed inside Missoula County.

This fact allows Bayern to do something completely unique in the state, which is reuse a substantial percentage of glass bottles and six-pack carriers. In 2012, Bayern Brewery invested in a $250,000, fourteen-metric-ton bottle-washing machine capable of cleaning and sterilizing eight thousand bottles an hour.

"To tell the truth, this is the smallest machine I've ever worked with," Knöller told the local newspaper after its launch, referencing the breweries in Germany where he had trained that had washers cleaning fifty thousand bottles an hour.

In Missoula, unlike Germany where beer bottles are often reused more than thirty times, glass reuse and recycling is not yet in full effect. There are only a handful of locations willing to accept glass for recycling. Bayern Brewery changed that because it did not want its estimated 2.5 million bottles to end up in the Missoula landfill (number based on Missoula consumption alone), making its local bottle needs roughly fifty thousand bottles per week.

Bayern Brewery has commissioned famed local artist Monte Dolack for all but two of its beer labels. *Courtesy of Bayern Brewing.*

Thanks to its "Ecopack," a waxed cardboard box available to any patron for a three-dollar-deposit, customers can bring any brown, non-embossed, pry-off, twelve-ounce bottles (not just Bayern bottles) back to the brewery by the case and receive a five-cent refund per bottle and ten cents per Bayern brand six-pack carrier. On average, two hundred cases are now returned to the brewery each week.

The waxed cardboard box was an idea based on boxes used in Alaska for transporting freshly caught fish, which are both durable and water-resistant. In less than a year, the "Ecopack" concept has taken off and now provides Bayern Brewery with 30 percent of its total bottling needs.

"It's what we're used to in Germany," says Thorsten Geuer. "You buy beer by the case and return the bottles when you're done."

As a complement to the fact that Bayern beer is itself artistic, all but two of Bayern's iconic beer labels were created by noted Montana artist Monte Dolack, widely considered to be a key figure in the visual arts of the American West and whose work often features whimsical animals in natural and artificial settings.

Bayern's taproom serves forty-eight ounces of beer per patron per day and is family-friendly. Through a large window, one can watch beer being bottled and brewed almost every day.

BIG SKY BREWING COMPANY

5417 TRUMPETER WAY
WWW.BIGSKYBREW.COM
MISSOULA (POPULATION 67,290)
406-549-2777
SIGNATURE BEERS: MOOSE DROOL, SCAPE GOAT, SLOW ELK, BIG SKY IPA,
 TROUT SLAYER, POWDER HOUND
11:00 A.M. TO 6:30 P.M. MONDAY–FRIDAY, 11:00 A.M. TO 6:00 P.M. SATURDAY,
 CLOSED SUNDAY

Big Sky Brewing Company is Montana's largest brewery and the forty-seventh largest in the United States (based on 2012 sales volume), but it might have never been if not for a fateful road trip and a blown transmission.

Two Michigan State college buddies, Neal Leathers and Brad Robinson, spent a couple summers during school driving up to Alaska for work. It was the late-1980s, and craft breweries in the Northwest were starting to gain ground. Full Sail Brewing Company had just opened and quickly became a favorite of Neal and Brad's, along with Chinook Amber Ale (now called Alaskan Amber). On their last drive from Michigan to Alaska, their transmission blew just outside of Missoula, Montana, so they spent a few days in town waiting for repairs, and that was the proverbial spark.

When they got back to school, both Neal and Brad began home brewing on a regular basis. While pursuing a degree in zoology, Brad decided he loved the west and wanted to transfer to the University of Montana–Missoula. In 1990, on his first night living in Missoula, Brad visited the Iron Horse Brewpub (which was attached to Bayern Brewing at the time), and after "a few Bayern beers," Brad called Neal back in Michigan (at 3:00 a.m. local time) to tell him, "There's a brewery in Missoula! And I think Missoula could have two breweries!"

Two weeks later, Neal also moved to Missoula, and casually they hatched a plan for a seven-barrel brewery, one that would focus on English-style ales as opposed to Bayern's traditional lagers.

Big Sky Brewing is the forty-seventh-largest craft brewery in the United States, producing almost forty-seven thousand barrels of beer annually. *Courtesy of Big Sky Brewing.*

Toward that goal, in 1991, both Brad and Neal began producing and starring in a local television series called *Beer Talk*, which aired weekly on MCAT (Missoula's local cable access television station). Each week on the show, Brad and Neal would open and taste three different craft beers or imports and talk about what they liked and did not like about them. This show quickly set viewership records and featured many of the most successful call-in programs in MCAT's history. But it did not get them a brewery. They needed someone else, and Bjorn Nabozney was that someone.

Bjorn was working toward completing a degree in finance at the University of Montana–Missoula. As his senior project, Bjorn was assigned to write a full business plan. He had met Brad and Neal at Sportsmen's Surplus and High Country Sports, where the three worked together. Bjorn had been hearing of Brad and Neal's plans for a brewery for a couple years by that point, so he decided to make that his business plan project.

After fifty-plus rewrites of the business plan and countless test home brew batches, the three partners raised enough capital to make their dream a

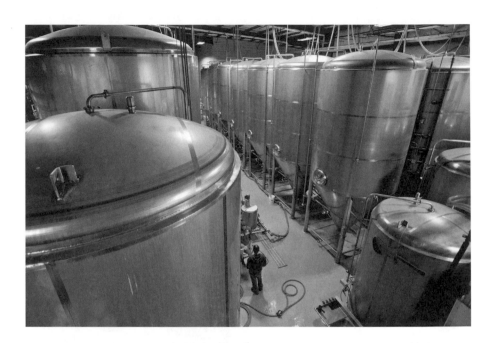

Above: Big Sky Brewing distributes to twenty-four different states, a goal the founders set for themselves before they opened in 1995. *Courtesy of Big Sky Brewing.*

Left: Big Sky Brewing's most popular beer is Moose Drool Brown Ale. *Courtesy of Big Sky Brewing.*

reality. Just in time, as Neal recalls, since the three men had also just gotten married and needed to begin careers.

At first, the business was to be named Rogue Elephant Enterprises, but Rogue Ales had already opened in Newport, Oregon (1989), and that name did not reflect what they loved about Montana, so they decided to give their brewery a name that embraced two things—both their goals as a brewery and the state itself. Big Sky Brewing Company did just that, as they always wanted the brewery to be big, just like Montana.

In fact, it was part of their original business plan to be distributed to exactly half of the United States, and today they are.

In 1995, Big Sky Brewing opened for business at 120-A Hickory Street, and its first beer, Whistle Pig Red Ale, "was a flop for us," says Bjorn Nabozney. "It was totally under-carbed!" Two months later, Big Sky Brewing debuted a couple more beers that would become Moose Drool Brown Ale and Scape Goat Pale Ale, both of which immediately crushed Whistle Pig, and so the red ale was retired in less than a year.

With a couple signature beers in place, Big Sky Brewing now needed attractive labels.

"We wanted Monte Dolack [who was working with Bayern]," says Nabozney, "but we couldn't afford him, so we looked to family for help. I called my mom, who was an artist, and we told her we wanted critters. We want images of critters for our beers."

Nabozney's mother was visiting his sister in Billings, and she happened to pass by a bar named Moose Breath Saloon, which gave her the idea of drawing a moose. Her drawing of a moose drinking in a pond was shown to Bjorn, Neal and Brad, and Neal took one look at it and said, "It's a moose, and he's drooling, let's call it Moose Drool," and the namesake was born.

For its first four years in business, Big Sky beer could only sell growlers to-go and give away free samples in its taproom. By the time Montana law changed in 1999 and allowed breweries to start selling forty-eight ounces of beer per person, per day for on-site consumption between the hours of 10.00 a.m. and 8:00 p.m. if that brewery produced less than ten thousand barrels annually, Big Sky Brewing was already over that ten-thousand-barrel limit so they could not sell a pint of beer in its taproom. That is why today Big Sky Brewing has the only taproom in the state that does not charge for the beer it serves.

Within a couple years after the law changed, Big Sky Brewing realized it could not get where it wanted to be, even though at the time it was the largest draft-only brewery in the United States, without bottling its

Big Sky Brewing moved its production and taproom to this 34,000-square-foot facility in 2002. *Courtesy of Big Sky Brewing.*

beer. It had also recently appointed Matt Long, who had previous brewing experience in California and had already worked with Big Sky Brewing for a couple years, as the new head brewer. This allowed Bjorn and Neal to plan and grow the business while relying on Matt's technical and creative expertise to brew the beer.

In 2002, Big Sky Brewing Company opened and moved to its new production facility on Trumpeter Way, leaving its seven-thousand-square-foot home on Hickory Street for a thirty-four-thousand-square-foot brewery with a bottling line. With this change came another: Brad Robinson left the commercial brewing industry to move to Helena, join the nonprofit sector and once again take up home brewing.

In the first year at the new facility, Big Sky was brewing twenty thousand barrels of beer. For the few years before it could get its new facility funded and built, Big Sky had contracted its bottle production at the Portland Brewing Company. Every week for two years, someone from Big Sky would travel to Portland to oversee the brewing and packaging process. Many at Big Sky were thankful when it could start brewing and packing in-house in Missoula.

Always growing and perfecting, Big Sky Brewing took a leap in 2003 with the concept of the aluminum bottle. At that time, it was the only company in

North or South America to use a classic glass-bottle-shaped aluminum vessel for beer. Understanding that its core audience is the active outdoors-person, Big Sky wanted to try something different than the traditional aluminum can.

These aluminum bottles were available, mostly to Missoulians, from 2003 to 2006. However, the increased cost of their production and shipment from Spain, where they were made, did not make it a profitable venture. In fact, the aluminum bottle cost four times as much as glass to bring to market.

Big Sky once again focused its efforts on bottling, kegging and growing its distribution footprint. By 2010, it finally launched into twelve-ounce cans. New Belgium Brewing had recently started its canning process, and neighboring Missoula brewery, Kettlehouse Brewing, had already been canning its main beers in sixteen-ounce format since 2008. Big Sky Brewing waited to ensure its canning process would be done right, with as low dissolved oxygen levels as possible, thereby giving its beers a longer shelf life. Today, its canned beers are the fastest-growing component of the Big Sky Brewing Company.

In 2012, Big Sky Brewing produced 46,700 barrels of beer, 70 percent of which was bottled and canned. Its primary market, however, is still rooted in Montana, with in-state consumption accounting for 25 percent of total sales (Washington is second with 9 percent). And though Moose Drool Brown Ale is its top-selling beer, over the years Big Sky has produced hundreds of different beers.

For what's next, Neal Leathers says, "It's a bit of a mystery. We've already gotten where we want to be, so we'll focus on being a world-class brewery and have as much fun as possible in the process."

Kettlehouse Brewing Company

Southside: 602 Myrtle
Northside: 313 North First Street West
www.kettlehouse.com
Missoula (population 67,290)
406-728-1660
Signature beers: Cold Smoke Scotch Ale, Double Haul IPA, Eddy Out
 Pale Ale
Noon to 9:00 p.m. Monday–Sunday

When Tim O'Leary started in 1995 what would become the Kettlehouse Brewing Company, it was a BOP (Brew on Premise), where community brewers could buy grain, grind it on-site, brew whatever beer they desired in one of the ten copper kettles and, when it was time to bottle it, come back to the shop. The BOP concept was certainly known to many in the brewing community in the 1990s, but it never really took off like craft breweries did. In fact, there were only about fifty-seven BOPs in the United States by 1997. However, for four years, O'Leary's BOP was a central figure in Missoula's beer scene.

Housed in a small building on Myrtle Street (where Kettlehouse Brewing still resides) alongside Missoula's infamous Big Dipper Ice Cream, O'Leary decided to take the leap into commercial brewing full-time and founded the Kettlehouse Brewing Company in 1999. But before he could brew more beer, he needed to find a brewing system, so he turned to fellow Missoula brewer, Jürgen Knöller of Bayern Brewing, and traded a Harley Davidson motorcycle in exchange for a fourteen-barrel brew system, so the legend goes.

O'Leary realized he needed one more thing in order for Kettlehouse Brewing to be successful: he needed the state law changed so he could sell pints in his taproom, so he became one of the main instigators for that change. On the day the bill was signed into law in Helena, O'Leary was there, but he immediately called his staff back at the brewery in Missoula and told them to start selling pints. Likely, Kettlehouse Brewing sold the first pint of beer in the state of Montana since the original restrictions went into effect.

With all that in place, commercial brewing began. However, because the brew system was in the building's common area, brewers would have to come in at 5:00 a.m., brew and clean up before 2:00 p.m. when the taproom opened to the public. In the early years, patrons often used the brew kettles as a place to set their beers.

One of Kettlehouse's first beers was called Bitters Pale Ale, named after a dog belonging to the BOP customer who helped create the recipe. This beer was rebranded into Eddy Out Pale Ale about ten years later.

By 2005, Kettlehouse was brewing 1,200 barrels of beer a year, and the brewery underwent a major remodel to move all of the brewery operations to the back of building, making more room for patrons and streamlining the brew process. In this year, it also hired Paul Roys, the brewery's current head brewer, and production once again increased.

In July 2009, Kettlehouse opened a second taproom and production facility (dubbed the "Northside"). The building sits atop the Orange Street overpass and was a former fruit and vegetable storage warehouse built in 1909 and designed by architect A.J. Gibson. The building included a "Banana Room" for ripening bananas, which the brewery now uses for its barrel-aging programs. This new location allowed Kettlehouse to focus on brewing its flagship beers in greater capacity and house a larger canning line.

Kettlehouse was the first among Montana's modern breweries to can beer, which it began back in 2006. At that time, the brewery produced 4,400 barrels annually and canned its three signature beers—Cold Smoke, Double Haul IPA and Eddy Out Pale Ale—in sixteen-ounce "pounders." O'Leary attributes his desire to can to memories of picking up cans along the highway with his mother and recycling them for cash, understanding that not everything should be thrown away. And for a more personal motive, O'Leary wanted to be able to take his beers on river trips, for which glass bottles are not suited.

Al Pils, Kettlehouse Brewing manager, enjoys a "pounder" of Eddy Out while fishing the Clark Fork River. In many popular recreation areas in Montana, glass bottles are not allowed. *Courtesy of Jay Dixon, Dixon Adventures.*

Kettlehouse Brewing's Cold Smoke is the most-tapped beer in the state, holding 180 tap handles in Missoula alone. *Courtesy of Alan McCormick.*

In fact, carrying glass bottles on the river can be illegal in parts of Montana. In 2005, the year before Kettlehouse began canning, state officials banned glass bottles on the iconic Blackfoot River, the notable centerpiece of Norman Maclean's *A River Runs Through It.*

With the new facility came sales growth for Kettlehouse's own home market. It saw a 30 percent increase in demand for its beer, just in Missoula alone, so Kettlehouse decided to scale back its distribution to focus more heavily on its hometown. Today, 70 percent of all Kettlehouse beer is sold in Missoula, and the brewery has now reached the 10,000-barrel limit, clocking in 9,990 barrels in 2012.

The focal point of the demand for Kettlehouse beer is certainly on Cold Smoke Scotch Ale, and to the envy of many other breweries in Montana. Cold Smoke claims 180 tap handles in Missoula alone, second only to Bud Light. It is a beer that has become synonymous with this college town, much in the same way Big Sky Brewing's Moose Drool is Montana's perceived state flagship beer.

But Kettlehouse Brewing brews more than just Cold Smoke. In fact, in 2012 the brewery produced more than seventy beers and variations, including cask, barrel-aged and Randall offerings. Outside its three most notable beers, true Kettlehouse fans often hit the Myrtle Street location to try Olde Bongwater Hemp Porter and Fresh Bongwater Pale Ale, both brewed with pelletized industrial hemp from Canada (and no, there is no measurable THC in these beers, if one is curious).

As to why breweries like Kettlehouse do so well in their respective communities, head brewer Paul Roys says, "Everyone is bringing it back to home, which is cool. You can walk down the street and meet the guy who brews your beer. And for Montana especially, we live right in the middle of the two main ingredients for beer—barley and great water. We can meet the farmers that grow our grain, or drive over to Washington and meet the hops growers, shake their hand, and say this is how much product we'd like to buy."

Kettlehouse makes a commitment to buy local whenever and wherever it can, and beyond that, it is committed to buying mostly American grain and hops.

"What's nice about brewing beer," says Roys, "is that it can be as hard science as you want it to be or as lackadaisical cooking in your home kitchen as you want it to be."

DRAUGHT WORKS

915 TOOLE AVENUE
WWW.DRAUGHTWORKSBREWERY.COM
MISSOULA (POPULATION 67,290)
406-541-1592
SIGNATURE BEERS: CLOTHING OPTIONAL PALE ALE, GWIN DU STOUT, QUILL PIG
 CZECH PILSNER, SCEPTER HEAD IPA, SHADOW CASTER AMBER
NOON TO 9:00 P.M. MONDAY–SUNDAY (GROWLER FILLS ONLY AFTER 8:00 P.M.)

Draught Works was the first brewery to open in Missoula in the sixteen
years since Kettlehouse Brewing opened. *Courtesy of Draught Works*.

In October 2011, Draught Works became the newest brewery to open in
Missoula since the Kettlehouse Brewing Company in 1995. Redeveloping
an old 1931 recycling center on Missoula's "Northside," which is on the
National Register of Historic Sites, Draught Works is a product of friendship
and family history.

Owners Jeff Grant and Paul Marshall met when they worked for the same
company in Missoula. Jeff's father had owned the now-defunct Milestown
Brewing Company in Miles City, Montana, and gave Jeff a homebrew kit for
his twenty-first birthday. That set things in motion.

Jeff cut his professional brewing teeth at the Four Peaks Brewery in Tempe,
Arizona, after attaining a brewing education at the Siebel Institute in Chicago
and Doemens in Germany. In early 2011, he moved back to Montana.

Paul, who worked in Human Resources and knew the ins and outs of
running a good business, shared Jeff's passion for beer, even growing his own

hops for home brews. One day, Paul's wife told him to quit his job and go to brewing school, and he listened. He went to the Seibel Institute and started writing the business plan for Draught Works with Jeff.

In May 2010, they found the old Missoula Recycling Center at 915 Toole Avenue. The building lent itself to an industrial feeling, which they wanted, but it needed work, a lot of work. For months Jeff, Paul, friends and family pulled nails and power washed decades of grime and dust away. The floor had three layers of wood planks that needed to be pulled so concrete could be laid. The pulled planks were given to neighboring business Blue Dog Furniture, which turned them into finished pieces for the brewery.

"Pretty much every piece of wood in the brewery, from the tables, the bar and the doors," says Jeff, "came from the reclaimed floor we pulled up."

The name, Draught Works, reflects the idea that Jeff and Paul are in the industry of making beer. The brewery gets calls every week from people asking about what it means, how to pronounce it or why it is spelled that way.

One of the most notable features of Draught Works is the lack of walls or windows between the seating area and the brewery. This is on purpose. Jeff and Paul wanted their patrons to feel part of and witness the brewing of the beer they were drinking.

"It's right there in their lap," says Paul, "and it goes hand in hand with the educational component that's important to us. We make sure our bartenders know how each beer is made so they can engage people in conversation about the nuances of each beer. The coolest thing that happens here is that we can have a curious macro-drinker come in here, try a taster tray of our beers and our server can talk about each of them intelligently. That is a victory is for us."

Since day one, Draught Works served its five flagship beers: Clothing Optional Pale Ale, Gwin Du Stout, Quill Pig Czech Pilsner, Scepter Head IPA and Shadow Caster Amber. It chose five because it was a manageable number that also provided a spectrum of styles so there could be a beer for everyone's tastes. Every Wednesday, the brewery pours one unfiltered, cask-conditioned beer from its beer engine, again to educate the public about the variety of ways beer can be served. Cask-conditioned beer does not have any added gases or carbonation, which differs from "regular" draught beer where carbon dioxide and nitrogen are added for carbonation and to push the beer out of the keg, through the tap and into a glass. With a beer engine, beer from a cask is hand-pumped through a tap and into a glass, resulting in a smoother "mouthfeel" of the beer and dense head. This was the traditional way to serve beer up until the 1960s.

In 2012, Draught Works produced 750 barrels of beer, and 100 percent of that beer was sold and served in the taproom, as the brewery does not distribute its beers at all. It is not found on tap anywhere else, in Missoula or elsewhere, and Jeff and Paul planned it that way from the start. They are about brewing quality beer and taking care of the people who walk through their doors.

They have the capacity to brew up to five thousand barrels in their current space and would like to start distribution of kegs to bars and restaurants soon. They vow never to bottle, and they might one day can but not from their current location.

"We're still new," says Jeff. "Missoulians, though, have come and given us a try. Even though it had been over a decade since a new brewery opened in town, the craft beer scene was very strong, and I give props to the locals for not writing us off and finding out firsthand what we had to offer."

WILDWOOD BREWING

4018 U.S. Highway 93 North
WWW.WILDWOODBREWING.COM
Stevensville (population 1,820)
406-777-2855
Signature beers: Organic Ambitious Lager, Organic Mystical Stout,
 Organic Bodacious Bock
4:00 to 8:00 p.m. Monday–Sunday

Wildwood Brewing founder Jim "The Beer Doctor" Lueders has a master plan, and brewing quality, organic beers is the vessel to bring it to life. With over twenty years of consulting experience for the craft beer industry under his belt, designing and beginning operations for nearly two dozen breweries worldwide, from Mexico and Trinidad to Japan and Africa, Lueders thought it was time he opened his own brewery.

On March 16, 2012, Wildwood Brewing opened its doors, marking the state's first organic brewery to produce all organic beers (While Blackfoot River Brewing is a certified organic brewery, not all of its beers are organic). The Wildwood brewery building is built from a 1901 timber frame barn Lueders bought in Wisconsin, disassembled and brought home to the Bitterroot Valley to reconstruct, adding straw bale walls for insulation. The

project took ten years of planning and two years of construction, all while Jim Lueders traveled the world helping others open their own breweries.

But even before his globetrotting consulting business took off, Lueders was a home brewer in Missoula finishing up his studies at the University of Montana and having dreams about opening a brewery in town. To further his skills and hone his passion for brewing, he helped found the local homebrew club, Zoo City Zymurgists. He also helped found a four-day beer festival in Missoula called the Greater Montana Brewers Cup (predating the BRIW fest), and he had a major hand in building up Montana's oldest brewery, Bayern Brewing.

When Bayern Brewing first opened, Lueders served as the assistant brewer to Jürgen Knöller for the brewery's early batches, even owning a small part of the company since the original owner, Reinhard Schulte, was not a U.S. citizen and therefore could not own 100 percent of the company.

It was also Knöller who also helped Lueders get into his famed alma mater, the Doemens' Masterschool for Brewing and Soft Drink Technology in Munich, to complete his education in brewing.

After returning to the United States, Lueders did not land back at Bayern, or even Montana. Instead, he landed into a role he would nurture for decades, being "The Beer Doctor." His first job was to set up and start the Saxer Brewing Company in Portland. As brewmaster, Lueders brewed the company's first eighty-five batches before leaving to work on his consulting career. He went on to help places like Zion Canyon Brewing Company, southwest Utah's first and only brewery. Zion Canyon brewery owner Dale Harris once told a Missoula newspaper that Jim Lueders "knows stuff about beer that people just shouldn't know about beer."

One of Lueders's current projects involves the Kingdom of Bhutan in South Asia, along the eastern end of the Himalayas. As a guest of the Bhutanese government, Lueders was invited to help the kingdom create a new cash crop for its native varieties of buckwheat, once a staple of the highlands of Bhutan. Lueders is now helping create an organic, nonalcoholic Bhutanese beer made from buckwheat extract.

But this is not Lueders's master plan. That has to do with his own brewery, a brewery he pieced together with the very brewhouse he first installed at Saxer Brewing Company and bought in 2002, holding onto it for ten years before being able to brew on it again.

"Ninety-two percent of what goes into producing beer is waste," says Lueders. These waste streams are prime resources for agro-industries, and to explore how a cluster of industries can fit within a brewery's framework

Lueders was recently awarded a government grant to pursue aquaculture research at his brewery.

"The brewery model is a good one because a lot of the waste streams that come out of here are organic matter and can be used in very interesting ways," says Lueders. "For example, barley malt is a major ingredient for making beer, and what is left after brewing is spent grain. It comes out hot, and the brewer has taken out most of the good stuff that was in the grain. What's left is about two percent carbohydrate and less than one percent protein. Essentially, we are left with a husk material of cellulose bound with lignin. While many give their grains to farmers, it's not a great feed. It has little nutritional value. What is a perfect use for spent grain is to grow mushrooms on it because fungi are in the natural kingdom of organisms that can break cellulose from lignin. They live on that. It's a new cash crop."

The other major waste stream breweries produce is wastewater. Lueders sees the potential to involve wastewater into an anaerobic digester that creates a biogas, methane, which can be used to heat the boiler in the production of beer. The water can also be used to grow phytoplankton and algae, which can be used as food sources in fish ponds. Two specific algae that can be cultivated are chlorella and spirulina, which are used in animal feed and for human consumption.

The fact that Wildwood Brewing is completely organic fits right into Lueders's grand scheme of sustainability; as he wants everything "downstream" to be organic, the materials he starts with must be too.

Though many of the malts used at Wildwood Brewing are Montana-grown, they are not malted in the state, as there is no organic malt house here. Therefore, Lueders buys his malt from the Gambrinus Malting Corporation in Armstrong, British Columbia, Canada, the smallest malting house in North America. The company only produces 6,200 tons of malt each year. Ironically, in Wildwood Brewing's case, barley is grown in Montana, shipped to Canada and then shipped back to the brewery for use in its beers.

Brewing on a twenty-six-barrel system, Wildwood Brewing currently produces eight styles of beer, canning three of them. The brewery's canning system is yet another expression of its commitment to sustainable brewing practices. The goal is to be primarily a canning brewery, eventually producing twenty thousand barrels of beer annually and canning 80 percent of the production, while devoting 10 percent to in-house use and distributing another 10 percent to handpicked accounts.

Lueders currently self-distributes his beers, not putting his beers on tap in more than two or three locations in any one town. He wants to drive most of his sales toward what he has canned.

And what about the beers? Already Lueders has won four different state beer festival medals for four different beers, including "Best Beer Overall" at the 2012 Garden City Brewfest in Missoula, Montana.

Once the Wildwood Brewing "model" is in place, complete with a closed loop waste stream, Lueders will be able to help other brewers and farmers worldwide join together and replicate what he is doing in the small rural town of Stevensville, Montana.

Blacksmith Brewing Company

114 Main Street
WWW.BLACKSMITHBREWING.COM
Stevensville (population 1,820)
406-777-0680
Signature beers: Brickhouse Blonde, Cutthroat IPA, Panty Dropper Pale, Pulaski Porter, Montana Amber
2:00 to 8:00 p.m. Sunday–Thursday, noon to 8:00 p.m. Friday–Saturday

In the heart of the oldest community in Montana is an old red brick building. In that building is a brewery—the Blacksmith Brewing Company, to be exact. The town of Stevensville is 172 years old. The red brick building is 106 years old, and the brewery is now 5 years old. Add all these up, and what one has is a community that really enjoys its beer.

Blacksmith Brewing Company came to be because founders Eric Hayes and Pam Kaye, who were dating at the time, stopped one day across the street from the vacant building to fill up their car at the gas station. Standing there, an idea sparked in Pam that they were looking at the location for the brewery they always wanted to open. The building was the McLaughlin Building, built in 1907 and serving Stevensville as a horse buggy salesroom, a steam laundry and then a blacksmith shop (from 1951 to 2000). After the blacksmith left, the building sat vacant until Pam and Eric set their eyes on it.

It took seven months of major renovations to get the building in shape to be a brewery, but when the doors opened on October 25, 2008, the community flooded in, and it has hardly settled down since, especially on

live music nights (Wednesdays and Saturdays), when the beers really get flowing and the crowd gets moving.

The name for the brewery was a given, and Kaye and Hayes took great care to preserve important historical elements in the building. That is why patrons can see the faint outline of the words "STEAM LAUNDRY" on the side of the building. The red bricks are all original and were manufactured locally when the building was constructed, and inside the 3,600-square-foot taproom, patrons can see brand marks left behind by the blacksmith who tested each brand he made on a wood wall.

Also inside are barstools with long and sometimes entangled histories. Kaye bought them off eBay from the famed Bombay Bar and Grill in Ventura, California. The bar was remodeling after twenty-five years and let go of "most" of their wood barstools in favor of new red-cushioned ones. One that was not sold went to a longtime patron of the Bombay Bar and Grill, sixty-one-year-old Jeff Cameron. When asking the bar owner to keep a chair, he explained, "I met, married and divorced a girl while in those chairs. It's been faithful." To get the chairs ready for the brewery, Kaye spent hours chipping off old gum from the bottoms, but they have served the taproom well since then.

Pam Kaye has since left the business, and Eric now oversees the operation and the distribution of all Blacksmith beers. He self-distributes, literally, to thirty-six handpicked accounts stretching south from Lost Trail Powder Mountain at the Montana-Idaho border all the way north to Kalispell.

When the brewery opened, neither Kaye nor Hayes was a brewer, so they brought in Mike Howard, who had worked for Stone Brewing in Escondido, California, before coming to Montana and working for Bayern, Kettlehouse, Big Sky Brewing and Bitter Root Brewing. Howard got Blacksmith Brewing off to a solid start, creating many of the brewery's current signature beers, including Brickhouse Blonde, an American-style Hefeweizen that outsells all its other beers about four-to-one. Howard has since left Blacksmith Brewing and is now working with Tony Olson to open Butte Brewing Company sometime in 2013.

The new head brewer is Sheldon Scrivner, a former brewer for the Montana Brewing Company in Billings. Working on a 10-barrel system, Scrivner brews 1,000 barrels of beer annually for Blacksmith Brewing. Their capacity hovers around 1,500 barrels. However, the brewery will have to make a decision soon about where it wants to go.

"We are right at that edge," says Hayes, "where either you jump and go into canning or bottling, or maybe add more fermenters. Or do you take a

deep breath and just take little bites? I think we'll just focus on the little stuff right now. I could go out and turn the brewhouse into a thirty-barrel system, but we won't yet. The brewery is good for the community, and it's good beer, and it's small-town made. We want to keep it that way."

Blacksmith Brewing prides itself on the consistency of the beers its serves and distributes. With Hayes behind the wheel, delivering each keg of beer to each account, it allows him to best control the quality of his product. Oftentimes he finds himself telling a bar or restaurant owner what they don't need as much as he tells them what they do need. For instance, he won't sell them a fifteen-gallon keg that might sit for four months before it is empty. He would rather stock them with one five-gallon keg and one backup to make sure the product is moving and fresh.

So while Blacksmith Brewing may not be in cans or bottles anytime soon, it will keep servicing its community and its accounts, and the beers will be consistent(ly good) wherever one is poured.

Bitter Root Brewery

101 Marcus Street
www.bitterrootbrewing.com
Hamilton (population 4,374)
406-363-7468 (PINT)
Signature beers: Sawtooth Ale, Nut Brown Ale, Session Pale Ale, India
 Pale Ale (IPA), Single Hop Ale, Porter
11:30 a.m. to 8:00 p.m. Monday–Saturday, 2:00 p.m. to 6:00 p.m. Sunday

When Bitter Root Brewery opened in 1998, there were few other breweries in the state. Its closest neighbors were Big Sky Brewing and Bayern Brewing, forty-six miles to the north. However, the reason Tim Bozik wanted to open a brewery in Hamilton was simple: this high-end woodworker, who had recently transplanted himself and his family from Arizona to rural Montana, wanted a place to enjoy good food and good beer with his family.

"I like beer," says Bozik, "and there was no place where I could take my family, have a nice dinner, and enjoy a beer, so I started one."

The name Bitter Root Brewery was an easy pick, referencing the nearby Bitterroot Mountain range, the Bitterroot River that flowed by Hamilton and

The Bitter Root Brewing Company was the first brewery in Montana to make an IPA. The brewery was criticized for trying it, being told it would be too "hoppy" for customers. *Courtesy Bitter Root Brewing Company.*

the showy, ground-hugging bitterroot wildflower (*Lewisia rediviva*), Montana's state flower.

When Bozik went to register the name, however, he found out that someone else already owned it; it was owned by the founders of Big Sky Brewing in Missoula.

"I called them up," says Bozik, "and they asked me why I wanted the name, so I told them I wanted to start a brewery down in Hamilton. They said, 'Great!' and immediately had the paperwork drawn up to give me the name. That was super cool. They were a great group of guys."

Bozik, who was not a brewer himself, made sure he put the right people in place who could produce the ales the brewery would be known for.

"As far as I can recall," says Bozik, "we were the first brewery in the state to do an IPA. I remember hearing from some of my colleagues, other breweries around at the time, that no one would like it. It would be too hoppy, they told me."

That didn't stop Bozik. He pieced together a ten-barrel brew system that included a brite tank he bought from Jürgen Knöller at Bayern that was in need of repair and a three-compartment dairy tank from Meadow Gold

Dairies in Missoula, which was originally used to make milkshake mixes, and that he used as a fermenter.

With skilled employees, a name, a vision and a brew system, Bitter Root Brewery began making Nut Brown Ale, Pale Ale, IPA and Sawtooth Ale. In the first year, it brewed about six hundred barrels. Today, Bitter Root Brewery produces around two thousand barrels, featuring at least thirty different styles a year.

Sawtooth Ale originally was named Summer Ale, but Bozik changed that when he realized people stopped buying it after summer was over because they thought it was out of season.

From the start, the brewery bottled its signature beers in twenty-two-ounce bottles, marking another first for the brewery.

"No one else bottled in that format then," says Bozik. "Later we helped Red Lodge Ales and Lone Peak Brewery get into these bottles." Bozik, as part of his original business plan, purchased a hand-bottling machine from Portland to get his beer into bottles.

In 2001, Bitter Root Brewery bought a newer ten-barrel brewhouse, one that was originally built by JV Northwest for the 1996 Summer Olympics in Atlanta.

Three years later, he added a restaurant and a patio; again, firsts for a brewery in Montana. Prior to that, Bozik partnered with "BBQ Bill," who would set up an outdoor grill on Fridays and Saturdays to sell plates of barbecue.

Bitter Root Brewery is in the middle of another expansion. By the end of 2013 the brewery plans to quadruple its brewing capacity (up to eight thousand barrels) and add a new canning line to can its signature beers in a twelve-ounce format. The brewery plans to keep the twenty-two-ounce bottles for its popular seasonal beers, like Red Dread Imperial Red.

Bitter Root's beers already see statewide distribution in Montana, and they make it to Idaho and eastern Washington. Once canning is underway, there are plans to launch into the Seattle and Boise markets.

Beyond that, "the plan is to still keep it local and fresh," says Bozik. "I never really want my beer to be distributed more than a day's drive. Longer hauls might be fine for macro beers, but not for what we're doing."

And though there is more "competition" in the Montana craft beer market these days, Bozik reflects on how when he got started all the other breweries were available and willing to help him, and that is what he likes best about this industry. As for the fact that Montana is second in the nation for breweries-per-capita, Bozik says, "It's not about how much you drink, but the quality of what you drink."

Higherground Brewing Company

518 North First Street
WWW.HIGHERGROUNDBREWING.COM
Hamilton (population 4,374)
406-375-5204
Signature beers: Clear Water Crystal Ale, Flash Flood Milk Stout, Dry
 Fly IPA, Summerfoot
11:00 a.m. to 8:00 p.m. Tuesday–Saturday, 1:00 p.m. to 8:00 p.m. Sunday

Sometimes breweries are created because of a desire to do something different or as a logical next step for an avid, longtime home brewer. But sometimes breweries are created out of sheer youthful ambition. For Higherground Brewing Company, it is the latter that applies. Founders Jasper Miller and Fenn Nelson are the youngest brewery owners and head brewers in the state of Montana. Both were just twenty-four years old when they opened the doors to their brewery in December 2011, and both are homegrown Hamilton natives.

The idea started in college, which for them was only a few years before they opened. As 2010 graduates, Miller and Nelson set out to begin careers, but what actually happened is that Nelson took a job at a shipping facility and Miller started commercial painting in Colorado.

"We quickly asked ourselves why we got college degrees if we were only going to pack boxes and paint houses," says Miller. "That lit a fire in us. I had been home brewing since college. When I was twenty-one, I entered and won a community home brew competition hosted by Big Sky Brewing for a Scotch Ale I made."

Miller pursued fermentation sciences at University of California–Davis and then interned at the Deschutes Brewery in Bend, Oregon (which offered Miller a job, though he turned it down to open his own brewery). After five rewrites of their business plan, they got a loan and found the old Grocery Emporium in Hamilton. The pair spent over four months renovating before they could open.

The spacious taproom reflects the local community. Two large quaking aspen tree trunks stand in the middle of the brewery, taken from Nelson's parents' property. The trees are symbols for the brewery's name, Higherground, as they are reaching for the sky.

"When we picked our name," says Miller, "we didn't want to do something that's been done—name ourselves after a river, mountain or a valley—and

Higherground Brewing is a popular lunch and dinner destination, offering wood-fired pizzas, salads and soups. *Courtesy of Higherground Brewing.*

Jasper Miller and Fenn Nelson, founders of Higherground Brewing Company, are the youngest brewery owners and head brewers in Montana. *Courtesy of Higherground Brewing Company.*

not that there is anything wrong with that, but we wanted to be a little more progressive. With 'Higherground,' people can make their own connection to it. For us, it means a way you can push and better yourself, better your product, better your community, to reach that higher ground."

As the head brewer, Miller brews several signature beers on a 5-barrel system, cranking out about 250 barrels in 2012. Flash Flood Milk Stout is a style that Miller was familiar with from his days in Colorado drinking Left Hand Milk Stout. The Clear Water Crystal Ale is the brewery's "gateway" beer, something clean, crisp and light.

Miller and Nelson currently self-distribute to about five hand-selected accounts in the Bitterroot Valley and Missoula. While they do see growth in their future, perhaps bumping up to a ten-barrel system and adding a canning line, they want to keep their beers in western Montana.

At the taproom, Higherground offers more than beer. It is well regarded for its wood-fired pizzas, soups and fresh salads. Having food was an element the brewery wanted to ensure it was family-friendly.

"We are not a college town," says Miller. "We have families and ranchers who need a safe, welcoming environment to eat and drink at, and that's what we provide."

SOUTHWEST MONTANA

BLACKFOOT RIVER BREWING COMPANY

66 SOUTH PARK AVENUE

WWW.BLACKFOOTRIVERBREWING.COM

HELENA (POPULATION 28,592)

406-449-3005

SIGNATURE BEERS: SINGLE MALT IPA, AMBER ALE, TARTANIC SCOTTISH STYLE
 ALE, NORTH FORK ORGANIC PORTER, BLUE COLLAR BITTER, CREAM ALE,
 ORGANIC PALE ALE (OPA)

2:00 P.M. TO 8:00 P.M. MONDAY–SUNDAY

Although Blackfoot River Brewing was founded in 1998, its brewing history stretches back years earlier when three passionate home brewers and friends decided that making beer was a good thing, and helping others make good beer would be a great thing.

In 1993, Brian Smith and Brad Simshaw were bitten by the homebrew bug. They were brewing a batch a week, every week, but the only way they could get the supplies they needed was to order from a catalog and have it shipped from Minnesota. Tired of the routine, the two decided it would be a better idea to open their own homebrew supply store, Howling Wolf Homebrew Supply, which they did in 1995.

It was no secret that Brian and Brad were the store's two biggest customers. However, they realized a need to expand their business in order to survive,

so they brought in fellow home brewer Greg Wermers, who helped create a vision for a real brewery.

Greg's personal beer history started as a thirteen-year-old growing up in the Black Hills of South Dakota when he would make his father stop the car along the highway so he could pick up empty beer cans for his collection. For thirty years Greg collected cans, many of which now adorn the Blackfoot River taproom walls.

As a home brewer, Greg's garage, with his homemade "lagerator" for cold-fermenting lagers, became the gathering place for monthly home brew club meetings.

"I think we went through the same three stages that most home brewers do," says Brad Simshaw. "They first think they can make cheap beer. Secondly, they realize they can make good beer. And in the last stage they realize this is a lot of fun. That was enough to build our desire and passion to have a brewery."

In 1998, the dream became a reality and papers were signed making it official. The brewery received its federal license on December 31, 1998, and the first keg from the brewery's seven-barrel system rolled out in January 1999 and was hand-delivered ten feet to the bar next door, Miller's Crossing, with the local newspaper, *Independent Record*, there to take pictures and cover the big story.

Blackfoot River Brewing was started by three avid home brewers, two of whom ran a local home brew supply store so they could buy supplies at wholesale. *Courtesy of Blackfoot River Brewing.*

During the first year, Blackfoot River Brewing could only sell kegs and growlers to-go because of the state law in effect at the time, but by year two, pints were on the table—literally.

The name Blackfoot River Brewing was chosen because "it had local flavor," says Simshaw. "It also reflected our philosophy for brewing beer, which is that we want to brew the best beer to style, and we are not looking for a fancy name to sell our product."

The brewery's logo features a howling wolf, a full moon and

an image of a river, all of which represent Blackfoot River Brewing and its history as the Howling Wolf Homebrew Supply.

Since day one, the lineup of beers has hardly changed. Most of the beers were recipes perfected by Brian, Brad and Greg as home brewers. If one beer is Blackfoot River Brewing's true flagship, however, it is the Single Malt IPA, which has a greater demand currently than it has supply. But that isn't driving the brewery to expand in a hurry to catch up.

"We don't want to get bigger," says Brian Smith. "We just want to get better."

In 2008, after nearly a decade in business, Blackfoot River Brewing did expand and moved into its current location on South Park Avenue. It operates on a 15-barrel Bavarian Brewing, steam-fired system, with a brewing capacity of approximately 3,200 barrels. In 2012, though, it produced 3,413 barrels. "According to the Brewer's Association listing of brewery production," adds Simshaw, "that is just five barrels less than Bozeman Brewing Company. Darn you[,] Todd Scott!"

The brewery's former fourteen-barrel brewhouse is going to Tony Olson, who has plans to use it to open Butte Brewing Company by the end of 2013.

"It is very nice to see our system stay in Montana," adds Simshaw.

Blackfoot River Brewing is not just focused on its signature beers. As former home brewers, the staff all still like to play around with new recipes. In 2012, the brewery released an average of one new beer every two weeks, twenty-eight in all. Blackfoot River Brewing produces two organic beers, Organic Pale Ale (OPA) and North Fork Organic Porter, and is certified in the state as an organic brewery, the first to do so in Montana back in 2002. It is also the largest brewery in the state that does not filter its beers, which adds body and flavor, according to Smith.

"I've actually been told by one of our fellow breweries in the state that they are, in fact, jealous of our ability to brew whatever we want," says Simshaw, "and by that they mean we are not forced to devote the majority of our time and space to the one beer by which everyone knows us. Being in our new place has allowed us to brew whatever we want to brew."

In January 2012, the brewery brought forward a notable appreciation for craft beer and switched over to style-specific glassware in its taproom, serving up four twelve-ounce pours per day instead of three pints.

One continuous "experiment" the brewery also likes to do at the taproom is make substitutions in its beers. For instance, with its popular IPA, the brewer will switch out the hops to Amarillo, Simcoe or El Dorado and serve it next to the original recipe, just to give patrons a chance to notice and appreciate how the beer's hop profile changes. Another popular offering is

to feature different stouts at the same time: dry stout, oatmeal stout, milk stout and others.

As far as Montana breweries go, Blackfoot River Brewing is part of the original class from the 1990s that are still going strong, and that makes it different. But seeing the recent growth in the state does not seem to bother Blackfoot River Brewing either.

"Even with nearly forty breweries in the state now," says Simshaw, "Montana is unique because you can look at every brewery and know they opened their doors because they said, 'I like beer and want to open a brewery, and I want it to be a nice place for my community.' This isn't like some brewpub that only wants to open because it thinks it can do better than the one down the street, so they find five investors to raise a few million dollars to try it. It's much more from the ground up here."

LEWIS AND CLARK BREWING COMPANY

1517 DODGE AVENUE
WWW.LEWISANDCLARKBREWING.COM
HELENA (POPULATION 28,592)
406-442-5960
SIGNATURE BEERS: MINER'S GOLD HEFEWEIZEN, TUMBLEWEED IPA, BACK COUNTRY
SCOTTISH ALE, YELLOWSTONE GOLDEN ALE, LEWIS & CLARK AMBER
2:00 P.M. TO 8:00 P.M. MONDAY–SUNDAY

When owner Max Pigman purchased his brewery in 2002, it was still Sleeping Giant Brewing Company, a struggling brewery that produced a half-dozen flagships and a couple seasonals. For two years, Pigman kept the name Sleeping Giant, but he soon found that once his beer ventured outside of Helena, nobody really knew the brand or its reference to the predominant mountain in the Big Belt Range to the north of Helena.

To further the issue, the original owners of Sleeping Giant filed for bankruptcy, and having the same name made it difficult for Pigman to contract with vendors, even though his business was separate. Plus, paring the words "beer" and "sleeping" wasn't a marketing goldmine.

To reposition the brewery, Pigman changed the name to Lewis and Clark Brewing Company to honor the fact Helena is in the only Lewis and Clark County in the entire United States, the 200th anniversary of the Lewis

Lewis & Clark Brewing was once Sleeping Giant Brewery in Helena. *Courtesy of Lewis & Clark Brewing.*

and Clark Expeditions was coming up and many people, even outside of Montana, understood the history behind those names.

The first beer Lewis and Clark Brewing produced is still its number-one seller, Miner's Gold Hefeweizen, a "gateway beer," according to Pigman, for those who may be new to craft beer or used to drinking macro-beers. The brewery is also known for Back Country Scottish Ale, Yellowstone Golden Ale, Lewis & Clark Amber and its number-two seller, Tumbleweed IPA, which had won a Gold Medal at the Great American Beer Festival the year before Pigman bought the brewery, beating out ninety-eight other IPAs.

"It's Montana's most award-winning IPA," says Pigman. "It has won in nearly every state beer festival we've entered it into, so we can easily justify that claim just by showing off all the awards it's received over the years."

Pigman is committed to using Montana-grown pale two-row barley for his beers. In the silo next to the brewery, he stores up to twenty-five thousand pounds at a time for his brewing needs.

"In Montana we are fortunate to have the best source for our number ingredient, the base malt," says Pigman.

In 2010, Pigman made a substantial investment in his brewery, putting in $1.9 million to move production and the taproom out of the old Sleeping Giant location, with its mine shaft motif and rough-hewn lumber bar tops, to a completely revitalized former paint warehouse that dates back to 1885.

The complex had undergone at least ten additions over 125 years and had served the Helena community as a smokehouse, a jailhouse, an icehouse and last a Columbia Paint factory from 1947 to 2008.

Though modernized, Lewis and Clark Brewing did not forget its historical roots. The six-thousand-square foot taproom is one of the largest in the state, but inside it one will still see the two-foot thick stone walls of the old jailhouse with the bars still bolted on and textures of layered paint from the paint factory on the staircases.

The brewery even gives a slight nod to its former name, with men's urinals made out of old Sleeping Giant kegs. Rumor has it that women occasionally have to be ushered out of the men's restroom because they are curious to see these ornaments.

"Montana is now as much a destination for people because of our breweries as we are for our scenery," notes Pigman.

Something else Pigman did when he moved to the new location was to scrap his former bottling line and install a new canning machine. Today, five Lewis and Clark Brewing beers are canned and distributed, from Missoula to Bozeman, and everywhere between.

"There's just so many places in Montana you can't have glass," says Pigman, "from fishing, rafting, camping and on the golf course. Canning makes sense for our state."

Growth since the move has been rapid and big. In its first year of canning, the brewery sold four times the amount of canned beer than it had in bottles the previous year. And brewing on a 25-barrel brewhouse, production increased 100 percent from 1,500 barrels in 2011 to 3,000 barrels in 2012, and Pigman expects to see at least another 60 percent increase by the end of 2013.

"We're trying to grow as fast, but as smart, as we can," says Pigman.

But with all the growth, Pigman still dedicates himself and the brewery to the Helena community, from hosting regular Ales for Charity Nights and raising funds for local nonprofits, to the annual "Neighborhood IPA" project, in which local hop growers bring in their crops for a collaborative IPA. The brewery started this project by teaching a hops-growing class, and the first year's yield produced sixteen pounds of hops. In 2012, over two hundred pounds were brought to the brewery. Those who contribute get pints and growler fills of the beer at a discount.

As for where Pigman wants to take Lewis and Clark Brewing next, that is yet to be decided. The first task is to have statewide distribution, east to west and north to south. After that, it is an untrodden path.

"What we do know," says Pigman, "is that right now we have all the right people in all the right places."

Quarry Brewing

124 West Broadway Street
WWW.QUARRYBREWING.NET
Butte (population 33,704)
406-723-0245
Signature beers: Galena Gold, Open Cab Copper, Shale Pale Ale, Open
 Pit Porter, Gneiss IPA
1:00 p.m. to 8:00 p.m. Monday–Saturday, 1:00 p.m. to 6:00 p.m. Sunday

Quarry Brewing opened in September 2007 because husband-and-wife owners Chuck and Lyza Schnabel wanted to share their passion for beer with Butte, a town with a rich and local brewing tradition but a town that had also been without a brewery since 1964. Technically, Quarry Brewing is the thirty-fourth and thirty-fifth brewery in the Mining City (it needed a new license when it moved in 2011).

Chuck was already a seasoned brewer before he moved back to his hometown of Anaconda in 1999, thirty-five miles northwest of Butte. He had worked at Ram Restaurant and Brewery (aka Big Horn Brewing Company) in Lakewood, Washington, first as assistant brewer and then head brewer, and then he took over the blind taste testing and lab work for eight of the company's breweries. By the time he left, Ram was operating sixteen different breweries.

While many brewers parlay their brewing experience into a melting pot of ideas for their own brewery, Chuck took something very specific away from his time brewing and working in Ram's corporate office: he knew he wanted to build a brewery unlike the one he had worked for. He wanted something small, manageable and that provided a gathering place for his community.

"We don't want to be the next Budweiser, or even the next Kettlehouse," says Chuck. "We are not looking to saturate any market we enter. At most we want to be regional and just grow smarter, not larger."

Chuck brews his Quarry beers on a seven-barrel system he salvaged in pieces in Canada. The kettle he uses is nearly three decades old, but he is in no rush to change. "We will modernize," says Chuck, "but only when the time is right. I do just over 600 barrels a year, but my cut-off will be about 1,200 barrels. Once I hit that I will just take care of the accounts I have."

The Quarry line-up includes Galena Gold, the brewery's "gateway beer," and Shale Pale Ale, the other Butte favorite. Among his select accounts in

Helena and Great Falls, the top seller is Gneiss IPA (sounds like "nice"). Chuck just signed on to start distributing in Bozeman, but with only four or five tap handles, and in fall 2013, he will have a few handles in Missoula. He is also considering adding a two-head manual canner so he can provide patrons with canned beers for their outdoor adventures or to send out as samples to accounts, but, again, he is in no rush.

The idea of being Quarry Brewing can be traced back to Chuck's childhood, growing up next to the limestone quarry in Anaconda. When thinking about what kind of brewery he wanted to offer, he realized that a brewery was much more than a name—it had an ambiance, a palpable presence.

To build that ambiance, Chuck and Lyza took great care when they moved their operation to the basement of the historic Grand Hotel on Broadway in 2011, a building they bought and are still renovating, so it would mimic entering a mineshaft, just like in a real quarry. Inside, there are community tables with old church pews instead of individual tables and chairs. Displays of rocks, minerals and gemstones line the walls. Toys are available for children to play with, and often those children are Chuck and Lyza's.

"Our logo is the shovel and pick," says Chuck. "It's the same symbol used on maps to mark a quarry. We're not looking for a lot of muss and fuss here, but I do think we are the only 'Q' brewery in the United States." (For the record, however, the Brewers Association does have listings for Quay Street Brewing Company in Michigan and a Quigley's Pint and Plate in South Carolina.)

And as much part of their brewery as the decor, patrons will often find Lyza and Chuck there, pouring beers, filling growlers and striking up conversation. "This is our passion," says Chuck. "It's what we do and we truly want to be part of this community."

PHILIPSBURG BREWING COMPANY

101 WEST BROADWAY
PHILIPSBURG (POPULATION 818)
406-859-2739 (BREW)
SIGNATURE BEERS: RAZZU RASPBERRY WHEAT, HAYBAG HEFEWEIZEN, TRAMWAY
 RYE PA, BAD FINGER STOUT
10:00 A.M. TO 8:00 P.M. MONDAY–SUNDAY

Philipsburg Brewing Company has sold twice the amount of beer it expected to in its first six months of business. *Courtesy of Philipsburg Brewing Company.*

Montana boasts about one brewery per 25,000 residents. Philipsburg Brewing Company, however, bucks that statistic. It is a brewery serving a town of only 818 residents, but not that anyone is complaining.

Philipsburg Brewing Company is a culmination of eighteen years of planning and three years of hard work. Co-owners Cathy Smith and her husband, Nolan, partnered with Rob Jarvis to build the brewery. Jarvis purchased the historic 125-year-old Sayrs Building back in 1991 with expressed plans to open a brewery. He even bought a couple copper brewing vessels and hung an "Opening Soon" sign in the window. But it wouldn't be until Cathy and Nolan Smith partnered up with Rob eighteen years later that the dream would become real.

Jarvis was not in the position to remodel his building, being based in Bremerton, Washington, but the Smiths could. For three years, the couple worked to get the building ready, putting on a new roof, redoing all the plumbing and electrical and laying a new wood floor. As a touch of class, customer service and acknowledgement of the area's rich mining history,

the bar features a unique, refrigerated copper strip that actually helps keep a patron's beer cold as he or she converses.

On August 25, 2012, the brewery's doors opened. Since the Smiths had no brewing experience, they hired brewmaster Mike Elliott, who left brewing at Kettlehouse Brewing Company in Missoula to take on the challenge. Ironically, people who were just born when Jarvis originally planned the brewery were now old enough to actually buy a pint there.

In their first half year in business, sales have been double what they projected, good news for a town that had not had a brewery since the Kroeger's Brewery quenched the thirst of silver miners through the 1860s to the start of the twentieth century. During this boom, Philipsburg actually had two breweries, six general stores, seven saloons, three blacksmith shops, a hotel and a newspaper. The town's population spiked to over 1,500, with "a new house going up every day," according to one observer. The breweries, like the boom, were gone by Prohibition.

Working on a 10-barrel system, the plan is to be "a 100 percent ale brewery," says Elliott. "We focus on fairly traditional styles, but with a twist." He has already brewed over a half dozen different beers and hopes to fill 650 barrels by the end of their first year. By year two, the brewery projects to produce over 1,300 barrels and begin distributing to select local and regional accounts.

Philipsburg Brewing will start a small barrel-aging program called the "Small Town, Big Beer Series," for which it will release a new barrel-aged beer on each autumn equinox.

"People here have been willing to step out and take new beer adventures with us," says Elliott. "Rural communities have often been associated as macro-beer drinkers, but we're offering some lighter beers that get them in the door so they can try everything we have to offer. And then we can educate them about craft beer. What we've seen here, I think, is a microcosm of the craft beer movement as a whole over the last twenty years. We've gotten people to switch from their light lagers and go all the way through the flavor spectrum in less than a year. That's fantastic."

Philipsburg Brewing beers are a blend of Montana-grown two-row barley, Oregon hops and waters drawn from the nearby Fred Burr Creek and Silver Spring.

Another notch in the belt for Philipsburg Brewing is founding the town's first beer festival, which it hosted in February 2013, drawing in twenty different Montana brewers and serving to a sold-out crowd in the old Fire Hall in Philipsburg.

"Our biggest asset," says Elliott, "is the intimacy of our taproom and the connection I, as a brewer, can have with customers. I literally get work right alongside the people who are enjoying the beer and educate them about the sweat, love, and hard work it takes to get that beer in their glass."

CENTRAL MONTANA

BOWSER BREWING COMPANY

1826 Tenth Avenue South
www.bowserbrew.com
Great Falls (population 58,950)
406-315-1340
Signature beers: Electric City IPA, Farmers Daughter Strawberry Blonde,
Red Raider Ale, Smoot Honey Ale, Without a Paddle Porter
Noon to 8:00 p.m. Monday–Sunday

As perhaps one of the greatest Christmas gifts he could give himself and
his community, Evan Bowser, at the age of twenty-six, opened the Bowser
Brewing Company on December 23, 2011, bringing back a brewing industry
that had been vacant in Great Falls for forty-three years.

Bowser had been working for a local architectural firm, but the recession
had forced the business to close. So he took the opportunity to go in business
for himself. He and his father had already been growing their own hops and
home brewing for years, and his wife was from Great Falls. For Bowser, it
just made sense.

Wanting to get out of the gate strong, Bowser dedicated his brewery to
showcasing the diversity beer can represent. On a ten-hectoliter system, he
wants to brew everything, and in his first three months of being open, he
turned out thirty different recipes.

Bowser Brewing was the first brewery to open in Great Falls since the last closed in 1968. *Courtesy of Alan McCormick.*

"At first I did not want to have flagship beers," says Bowser, "but after a year and a half, I saw we needed a few we could get behind." Bowser Brewing features sixteen different beers on tap, with five staying on year-round and the other eleven changing out every three weeks.

"We've brewed everything from a Horseradish Red to almost coming out with a Rocky Mountain Oyster Stout," says Bowser, "but Wynkoop Brewing in Colorado beat me to that."

Bowser says he will even take special requests from his customers if they have a favorite beer he hasn't yet brewed, although he has been known to brew beer for people even if they don't request it. For instance, in September 2012, Great Falls was host to Olympic U.S. women's soccer gold medalist Abby Wambach, who was visiting for a Get Fit soccer clinic. Bowser brewed up an "Abbie's Urbock" in her honor with hopes she would stop by and sample the goods. She did. After her visit she tweeted a "thank you" for the brewery tour and beer tasting. Bowser said the beer he made for Wambach "looks harmless, is smooth, but has a 'kick' with 7 percent ABV, just like the soccer star."

Something else Bowser Brewing Company prides itself on is the fact that it serves its patrons beer in twelve-ounce glasses, allowing them to drink their full forty-eight-ounce daily limit over four different beers instead of three pints.

Before opening, Bowser spent a lot of time traveling to other breweries around the state, wanting to replicate the elements he liked and differentiate where he thought he needed to. His overall theme in his taproom, however, is simply Montana. From local art adorning the walls and local live music playing up to four nights a week to using locally grown barley and putting its beer menus on the backs of old Montana license plates, when patrons walk into the Bowser Brewing taproom there is no mistaking where they are—they are in Montana.

To further drive that point home, Bowser uses his taproom to showcase many unique relics from Montana's brewing past. One of the rarest items on display is an old wooden beer barrel once used by the Lewistown Brewing Company (1894-1938), and he has a hand-blown glass bottle from that brewery to match. Also part of Bowser's "archives" is a seven-foot tall cowboy from a Great Falls Select billboard once displayed in town. The billboard had two sides, and the Belt Creek Brew Pub (adjacent to Harvest Moon Brewing Company) displays the other side.

It is not all relics and ambiance, however. Behind the Bowser Brewing Company beer is an award-winning head brewer, Dennis Holland.

"I bet you he's the highest-paid brewmaster in the state," says Bowser. "I knew selling craft beer in Great Falls would be tough, so I had to have the very best brewer I could find to brew it. When I give tours I tell people that we have one of the ten-best brewers in the country."

One of Holland's claims to fame, other than the countless medals he has earned as a brewer, is developing an iconic beer for the Great Lakes Brewing Company called Edmund Fitzgerald Porter. This porter is often cited by the Beer Judge Certification Program (BJCP) as the most stylistically correct representative of a porter within the porter category. In 1991, it won its first gold medal at the Great American Beer Festival. Today, the Great Lakes Brewing Company brews over 11,300 barrels of Edmund Fitzgerald Porter every year.

When Holland put his resume on ProBrewer.com, looking to make a fresh start, he reportedly had twenty-five offers for a head brewing position in three days. What helped Bowser Brewing win out in the end is its location. "We were the only brewery in the west to offer him a job," says Bowser. Holland has family ties both to Alaska and Spokane, so he welcomed the opportunity to live closer to them.

"Dennis has some amazing stories to tell," says Bowser, "and some that include drinking too much and taking women into a mash tun, using it as a hot tub. I can't remember who he said he did that with, but it was a name I recognized."

Bowser's distribution plan is to stock areas around, but not in, Great Falls. He wants the only place to get Bowser Brewing beers in Great Falls to be at the taproom. He has select, single accounts in Missoula, Bozeman and Billings, and he just signed on to distribute into Canada. For beer-on-the-go, Bowser Brewing is one of the few breweries in Montana that sells and fills "growlettes," thirty-two-ounce versions of the traditional half-gallon growlers.

As far as the future goes, Bowser has some very big plans. He is currently in negotiations to develop a sixty-barrel production facility in his hometown of Winifred, Montana, about three hours east of Great Falls. If all goes according to plan, he will then operate the largest brewing facility in the state.

There is no doubt that Bowser Brewing Company and Evan Bowser are out to push the envelope beer-wise. Furthermore, having a forty-three-year span between the Electric City's last brewery and Bowser's new one allows him to make a whole new first impression on the next generation of local craft beer drinkers.

THE FRONT BREWING COMPANY

215 THIRD STREET NORTHWEST
WWW.THEFRONTBREWING.COM
GREAT FALLS (POPULATION 58,950)
406-727-3947
SIGNATURE BEERS: MOUNTAIN MAN STRONG ALE, RIVER WATER IPA, HEAD
 QUARTERS PALE ALE, CRYSTAL MEADOW WHEAT, DAY HIKE
8:00 A.M. TO 10:00 P.M. MONDAY–SATURDAY, 8:00 A.M. TO 8:00 P.M. SUNDAY

Brandon Cartwright made a splash on the Great Falls scene in 2011 when he opened the Faster Basset Coffee and Crepe Haus. It introduced the community to the Pacific Northwest's iconic coffee brand, Stumptown Coffee. Wanting to do more than cater to the morning crowd, Cartwright went after the night crowd by adding the Front Brewing Company next door to his business in March 2012.

Jürgen Knöller from Bayern Brewing (left) pours cask beer with Senator Max Baucus (right) at the Twentieth Annual Garden City Brewfest in Missoula, with the author watching (center). *Courtesy of Alan McCormick.*

Left: Bozeman Brewing waited six years before it released its first IPA. Now Hopzone IPA outsells most of its other beers two to one. *Courtesy of Alan McCormick.*

Right: With Bozeman Brewing's take on the "Black and Tan," the company created the "Triple Layer Cake," stacking Nitro Dry Irish Stout over Hopzone IPA over a rich Baltic Porter. *Courtesy of Bozeman Brewing.*

Above left: Draught Works sells 100 percent of its beer from its taproom. *Courtesy of Draught Works.*

Above right: The Draught Works taproom has no walls, allowing patrons an unhindered view of the brewing process. *Courtesy of Alan McCormick.*

Left: Flathead Lake Brewing Company opened a brewpub in Missoula in 2010. *Courtesy of Alan McCormick.*

Opposite, top: Glacier Brewing Company does not like following trends, and as a small brewery, it can experiment with a variety of styles. *Courtesy of Glacier Brewing Company.*

Opposite, bottom: Glacier Brewing Company patterned this sign after the H.S. Gilbert Brewery in Virginia City, Montana, the state's oldest recorded brewery, built in 1863. *Courtesy of Glacier Brewing Company.*

Great Northern Brewing's "Gravity Flow" brewhouse shines in the tallest building in Whitefish. *Courtesy of Black Star Beer.*

The three quaking aspens in the Higherground Brewing Company taproom came from Fenn Nelson's family's property. *Courtesy of Higherground Brewing Company.*

Left: The Kettlehouse "Northside" building was a former fruit and vegetable storage warehouse built in 1909. *Courtesy of Alan McCormick.*

Below: Madison River Brewing blends its two passions: beer and fly-fishing. *Courtesy of Madison River Brewing.*

Above, left: Philipsburg Brewing Company is in the newly remodeled Sayrs Building, which was originally constructed in 1888. *Courtesy of Philipsburg Brewing Company.*

Above, right: This sticker-ridden refrigerator door at Red Lodge Ales Brewing Company leads to the bar's cooler. *Courtesy of Jared Spiker.*

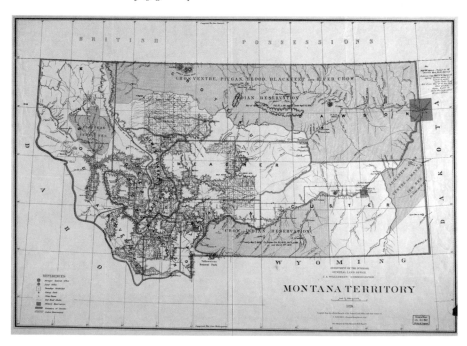

Draught Works offers a spacious patio connected to the brewery, which is often filled on sunny days. *Courtesy of Alan McCormick.*

In May 2012, the first annual Missoula Craft Beer Week celebrated local and regional breweries through special events and food pairings. *Courtesy of Alan McCormick.*

Opposite, bottom: Territory of Montana. By 1900, only eleven years after Montana became a state, there were twenty-one breweries in operation. At one point, that number rose to sixty. *Courtesy of Library of Congress.*

The Kettlehouse Brewing Company started in 1995 as a BOP (Brew-On-Premise) for home brewers. In 1999, it became an independent craft brewery. *Courtesy of Al Pils.*

Like many breweries in Montana, Desert Mountain Brewing offers a "Mug Club." *Courtesy of Desert Mountain Brewing.*

Red Lodge Ales bottles and distributes in Montana, Wyoming and North Dakota. This Broken Nail Double IPA is the Imperial version of its bestseller, Bent Nail IPA. *Courtesy of Montana Brewers Association.*

Trout Slayer is a filtered wheat ale, well suited for a hot day of fishing, or anytime. *Courtesy of Big Sky Brewing.*

Left: Flathead Lake Brewing Company's Missoula brewpub created a three-course beer dinner for the Second Annual Missoula Craft Beer Week in May 2013. *Courtesy of Alan McCormick.*

Below: Black Star Beer was Minott Wessinger's first beer at Great Northern Brewing Company. It was brewed from 1994 until 2003 and then re-launched in 2010. *Courtesy of Donnie Sexton.*

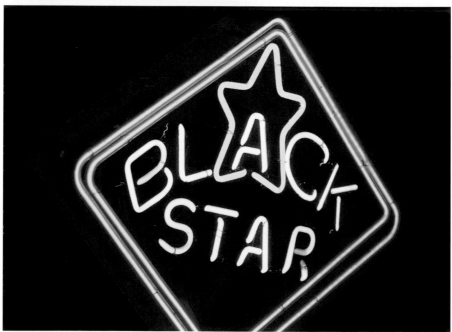

Beaver Creek Brewery in Wibaux serves a population of 541 people. It may be the most remote brewery in the United States. *Courtesy of Donnie Sexton.*

Great Northern Brewing Company in Whitefish benefits from being only forty minutes from Glacier National Park. *Courtesy of Donnie Sexton.*

While the majority of Carter's Brewing beers are consumed at the taproom, Michael Uhrich does self-distribute to select accounts around Billings. *Courtesy of Donnie Sexton.*

Visitors to the Flathead Lake Brewing Company in Woods Bay often come for the views as much as they do for the beers. The Flathead Lake is the largest natural freshwater lake west of the Mississippi River. *Courtesy of Donnie Sexton.*

Above: Sam Hoffman was only twenty-four years old when he founded Red Lodge Ales in 1998. *Courtesy of Donnie Sexton.*

Left: The Great Northern Brewing Company hosts an annual Black Star Beer Barter in February, giving fans a chance to barter for a year's supply of Black Star Beer. *Courtesy of Donnie Sexton.*

Above: Flathead Lake Brewing Company offers "fresh brews with a view" along the eastern shores of Flathead Lake. *Courtesy of Donnie Sexton.*

Left: The founders of Harvest Moon Brewing Company came up with the name, Pig's Ass Porter, after delivering their spent grains to a local pig farmer. *Courtesy of Donnie Sexton.*

Opposite, top: Kettlehouse Brewing Company is the third-largest brewery in Montana, producing ten thousand barrels of beer each year. *Courtesy of Donnie Sexton.*

Opposite, middle: The Quarry Brewing logo is a pick and shovel, the universal map symbol designating the location of a quarry. *Courtesy of Donnie Sexton.*

Opposite, bottom: Red Lodge Ales offers sample trays as a way for customers to try a variety of its beers. *Courtesy of Donnie Sexton.*

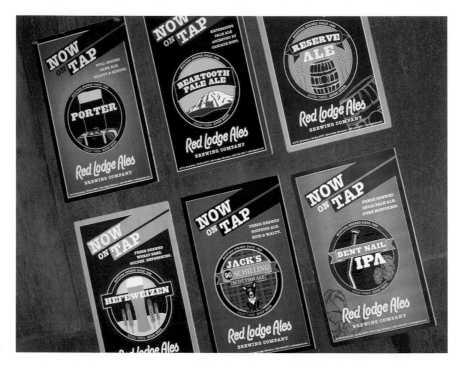

Red Lodge Ales' selection of year-round beers. *Courtesy of Donnie Sexton.*

Red Lodge Ales grows its own hops outside the brewery but only produces enough for one batch of beer a year. *Courtesy of Donnie Sexton.*

Its slogan is "Come for the coffee and stay for the beer. Come for the beer and stay for the coffee."

The brewery only uses local grains and water for its beers, which it produces for the Front Public House and select accounts in Great Falls.

Harvest Moon Brewing Company

7 Fifth Street
www.harvestmoonbrew.com
Belt (population 600)
406-277-3188
Signature beers: Beltian White, Pig's Ass Porter, Charlie Russell Red, Great Falls Select, Elevator IPA
10:00 a.m. to 4:00 p.m. Monday–Friday

John Ballantyne and Stan Guedesse are living proof that great minds think alike. Back in 1995, both men were looking for the same thing in the same area—used brewery equipment to start a new brewery, and new careers, in Great Falls. But it was Ballantyne who got to it first.

"I bought some used dairy equipment from Ed McHugh at Clover Leaf Dairy in Helena when they closed down," says Ballantyne, "and Stan had called Ed for the same equipment but was told I had just bought it. Ed gave Stan my phone number and he called. We talked over our ideas for a brewery and decided we'd just throw in together." And that they did, deciding on calling the brewery Harvest Moon Brewing Company and paying homage to the fact that they lived in the "bread basket" of Montana, surrounded by fields of wheat and barley.

The two started looking for a building in Great Falls, a town that was once home to Great Falls Breweries Inc., one of the largest post-Prohibition breweries in the state.

As Ballantyne and Guedesse searched, they could not find exactly what they wanted for a decent price, so they turned to Guedesse's hometown of Belt, fifteen minutes southeast of Great Falls.

"In hindsight, finding Belt was a very good thing," says Ballantyne, "because the town's water supply comes directly from wells sunk 400 feet below the surface in the Madison Formation," which is where the limestone-enriched water is incredibly pure and stays a constant year-round temperature. The

Madison Formation is composed of rain and snowfall collected on Thunder Mountain (8,050 feet elevation), part of the Little Belt Mountains, and as ground water it travels nearly forty miles 700 feet below the surface until pressure forces it up through cracks in rock layers and through beds of limestone, and it bubbles out at Giant Springs in Great Falls.

During the Lewis and Clark Expedition in 1805, Meriwether Lewis wrote of Giant Springs, "I think this fountain the largest I ever beheld, extremely transparent and cold, very pure and pleasant." Two hundred million gallons of water per day come out of the springs before flowing into the Missouri River 201 feet away and forming the Roe River, arguably the shortest river in the United States.

At one time, according to radiocarbon dating, it was believed that the waters in the Madison Formation stayed underground for 2,900 years before reaching the surface at Giant Springs, but those results were later thought invalid. What is certain, according to Ballantyne, at least, is that Belt has "good beer-making water."

Guedesse oversees all the brewing at Harvest Moon Brewing Company, while Ballantyne runs the business side. As a former Great Falls home brew supply storeowner, Guedesse had the experience to create unique beers for the brewery. Ballantyne was an avid home brewer and knew what a good beer should be. The duo got their start on a ten-barrel system in a rented eight-hundred-square-foot space. In 2000, they moved production down the street into a four-thousand-square-foot space and remodeled again in 2006 to double that size.

Today, Harvest Moon Brewing Company cranks out 6,500 barrels annually on a 30-barrel system. As a primarily production brewery, the company bottles and cans its beers and distributes all across Montana and into limited parts of Wyoming, Wisconsin, North Dakota and Canada.

Harvest Moon Brewing has been producing its flagship beer, Beltian White, brewed with coriander, Curacao orange peel and Saaz hops, since 1998, and it accounts for over 60 percent of the brewery's total sales.

Conversationally, however, Harvest Moon Brewing earned its stripes by creating one of the state's first commercial porters and calling it Pig's Ass Porter.

"We had already brewed this porter," says Ballantyne, "and we were out giving our spent grains to a local pig farmer when Stan asked, 'What about calling the beer Pig's Ass Porter?' and I said, 'Why not?'" The artwork for the label was created by Stan's uncle, and later the brewery commissioned several custom tap handles. The beer itself is somewhat sweet, with chocolate and coffee notes but without the stronger hop profile of a robust porter. The

recipe was meant to cater to the brewery's local distributor, who did not want to market a beer that would interfere with his Guinness Stout accounts.

In 2008, Harvest Moon Brewing also resurrected a legend among Montana's beer history by brewing Great Falls Select. Once the flagship beer produced in Montana by Great Falls Breweries, Inc., Great Falls Select was available as a Montana-made beer from 1933 to 1968. After that, production moved to the Blitz-Weinhard brewery in Portland, as the company had just purchased Great Falls Breweries, Inc. two years earlier in 1966. When production moved, the recipe changed. By 1980, Great Falls Select ceased to exist entirely, with the Blitz-Weinhard brewery citing a lack of revenue to adequately promote the brand.

The trademark for Great Falls Select found its way into Paul O'Leary's hands. O'Leary was the founder and brewer at Bridger Brewing in Belgrade, Montana, when it was open between 1993 and 1995 (not to be confused with the new Bridger Brewing in Bozeman, which opened in 2013).

"Paul came into the brewery one day," says Ballantyne, "but he didn't necessarily introduce himself. He was on one of our tours and asking some very intelligent questions. I commented that he really knew something about the brewery business, and then he introduced himself. I knew exactly who he was then, and I knew he held the rights to Great Falls Select because I had already researched it." Both men discussed wanting to do something with the historically significant name, and then it happened. O'Leary signed over the rights to use the name, and a new beer bearing the Great Falls Select name was brewed in 2008. While the original recipe was a light lager, the new Great Falls Select is a light pale ale meant to attract similar, easy-drinking audiences.

Visitors to the Harvest Moon Brewing taproom will find at least five beers on tap. However, the tasting room is small and open for minimal hours during the week, and it was meant to be. Ballantyne and Guedesse never intended for nearby Great Falls residents to make the drive over to the brewery to drink a few beers and then drive home. Instead, they always planned to take the beers they love to brew to the people who will hopefully love them too.

CHAPTER 5
YELLOWSTONE COUNTRY

406 BREWING COMPANY

101 East Oak Street, Suite D
www.406brewingcompany.com
Bozeman (population 38,025)
406-600-0181
Signature beers: This brewery does not designate any of its beers as
 flagship beers.
12:00 p.m. to 8:00 p.m. Monday–Sunday

In 2011, 406 Brewing Company hit the Bozeman beer scene with the intention of "going against the grain," says founder and head brewer Matt Muth. "I saw a different vision than a lot of the breweries around here."

What may strike most patrons at 406 Brewing is the lack of flagship beers. This is not an oversight. "We hardly ever even have the same beer on back-to-back," says Muth. "We're always changing. We are offering people an experience and don't want anyone tied to a specific flavor or specific label or style. We want to expose them to all the different beer variations that are out there."

To that end, the 406 Brewing Company brewed forty-five different beers in 2012, only repeating fifteen of them. Total production in 2012 was 380 barrels. It is a "let's just try it" attitude that is central to Muth and why he founded the brewery.

To showcase talents on both ends of the brewing spectrum, 406 Brewing often brews "session beers," those with about 4 percent ABV, which, for reference, is less than Pabst Blue Ribbon. This allows customers to enjoy a couple beers without the alcohol effect going straight to their heads.

At the other end of the spectrum, for its second anniversary the brewery released a limited number of hand-bottled Imperial IPA, brewed with Simcoe, Columbus and Centennial hops, that measured 9.5 percent ABV and had 250 IBU (International Bittering Units). For reference, most "hoppy" IPAs top out around 100 IBUs.

Another distinguishing factor for 406 Brewing is that it does not distribute its beers anywhere. Its beers are only available at the taproom.

"We wanted people to come here to the brewery and connect with the brewhouse," says Muth, "where they can see where it's made and make a real connection with the place."

Muth started home brewing while attending the University of Vermont (Vermont currently has the most breweries-per-capita in the United States). When he moved to Bozeman, he worked for Bozeman Brewing and Madison River Brewing before he opened his own brewery.

Originally planning to name the brewery Crazy Mountain Brewing, Muth had to change course when he discovered a California company had recently opened a brewery with the same name in Vail Valley, Colorado.

Though providing its share of "new" experiences for the craft beer consumer, 406 Brewing still roots itself in Montana's rich brewing history. Muth uses local resources when and wherever he can. For instance, the taproom benches are constructed from wooden beams taken from the historic Bozeman Brewery, the one Julius Lehrkind ran until 1919.

The same goes for what goes into the 406 Brewing beers. Some of the hops Muth uses are picked from the Bozeman area and used the very next day.

Muth is currently working on having a kitchen where he can serve fresh and local menu items, including beer bread made from spent brewing grains and locally made cheeses. Further into the future, Muth will look into distributing and possibly canning, if that makes sense for his business.

"We are going to act slowly," says Muth, "and we will go wherever the beer takes us. Instead of coming out and trying to do everything at once, if we stay focused and are able to produce, consistently, an exemplary product then we have a chance at staying in the game and being a viable choice for the customer. It's all about the beer."

Bozeman Brewing Company

504 North Broadway
WWW.BOZEMANBREWING.COM
Bozeman (population 38,025)
406-585-9142
Signature beers: Bozone Select, Bozone Plum St. Porter, Bozone
 Hefeweizen, Hopzone IPA
2:00 to 8:00 p.m. Saturday–Thursday, Noon to 8:00 p.m. Friday

Many may look at Todd Scott's brewing career in Montana and consider him a lucky man, and they are probably right to do so. With the exception of Jürgen Knöller at Bayern Brewing, no one else has been brewing commercially and continuously in the state as long as Scott has. From 1992 until 2001, he was the head brewer for Spanish Peaks Brewing Company in Bozeman. Spanish Peaks is most well known for its Black Dog Ale.

Scott was in charge of brewing one thousand barrels of beer a year for the company's brewpub. After ten years in Montana, however, Spanish Peaks Brewing decided to move its business to California so it could increase production to sixty thousand barrels annually and start distributing nationwide. Scott decided he didn't want to go back to California. He had already lived there while working as a sous chef in Tahoe and brewing at a brewery in Calistoga. He preferred Montana.

Scott freely admits that he was already dreaming of owning his own brewery while working at Spanish Peaks. With the move, he saw an opportunity. After he spent several months setting up the company's new brewery in California, he came back to Bozeman and bought all of the equipment he could from his previous employer, a seven-barrel brewhouse with which he was already very familiar.

Knowing the local market and knowing how to brew good beer were two things Scott could immediately check off his list. He also had his brewery's name picked out, Bozeman Brewing Company. What he did need, though, was a product.

"I needed beers that could hit the ground running," says Scott, so he made them. One of the very first beers he made after opening in 2001 was Bozone Select Amber Ale, and to this day it remains Bozeman Brewing Company's flagship beer. Its logo is reminiscent of the longtime Montana favorite Great Falls Select blended with the Highlander Beer produced by the Missoula Brewing Company. Other elements in the logo represented Montana's capitol, Helena, and the once-famous Billings Brewing Company.

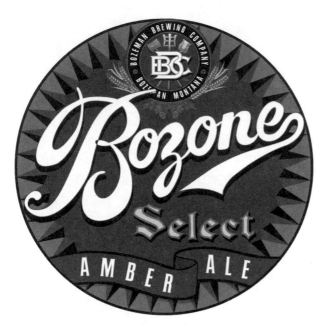

The logo for Bozone Select Amber Ale highlights different elements of a long Montana brewing tradition. *Courtesy of Bozeman Brewing Company.*

In addition to Bozone Select, Scott brewed up the Bozone Plum St. Porter and Bozone Hefeweizen, two staples of his brewing portfolio.

For his first five years in business, he was a production brewery, meaning he had no taproom. He brewed to supply accounts around Bozeman. Today, he distributes to Bozeman, Billings and Helena, and he sells whatever he can produce. With himself, his family and a few employees, Scott was making four signature beers and four seasonals, nothing more.

After he remodeled his taproom and brewing area in 2008, increasing to a 20-barrel brewhouse, production rose to nearly 2,400 barrels. Part of the increase may be due to the fact that Bozeman Brewing finally released its first IPA (in 2007), known as Hopzone IPA, a bold and fruity tribute to the hop-heavy British-made IPAs from the 1700s. That beer is now one of the brewery's most popular, outselling most of their other beers two-to-one.

In 2011, Scott added a canning line to his facility and started canning Bozone Select Amber Ale in six-packs of twelve-ounce cans. Devoted entirely at first to its flagship beer, Bozeman Brewing is not canning anything else until summer 2013. Scott credits this approach to his love for beers like Fat Tire and Anchor Steam and breweries like Sierra Nevada, where the flagship beer is front and center to the business.

Moreover, doing a slow rollout of his flagship beer falls right in line with Bozeman Brewing's general philosophy.

"We don't rush out," says Scott. "We believe our strength is our consistency, so we won't release anything until we are sure it is perfect. That's why we run

a three- to four-week production schedule. It gives us time to work on each batch we brew. Beer is a food item. It can start to deteriorate as soon as it's packaged, so we keep an on-demand inventory."

Scott touts having an "aggressive growth plan carried out in a conservative way." That means that when he goes into a market with his beers, he wants to saturate it, selling there for years before he picks up and moves into another one. His fear would be to introduce his product to a market and then have to pull out of it because he can't meet demand.

Scott's ultimate goal for his business, interestingly, really has nothing to do with beer. "I want my crew to make a good living," he says. "I want to be able to support my staff. That's why we'll do whatever we need to do or brew whatever we need to brew." Perhaps, in some measure, since Scott got to choose living in Bozeman over living somewhere else, he wants those he works with to have the same choice he did.

Bridger Brewing

1609 South Eleventh Avenue
www.bridgerbrewing.com
Bozeman (population 38,025)
406-587-2124
Signature beers: Vigilante IPA, Bobcat Brown, Bridger Pale Ale
11:00 a.m. to 9:00 p.m. Monday–Sunday

One of the newest breweries in Montana is also one that is as excited about their food as they are their beer. Opened on March 2, 2013, Bridger Brewing pairs its craft beer with its craft pizzas, a perfect combination considering the brewery also happens to be right across the street from the Montana State University in Bozeman.

Owners Dave Breck, Jim Eberhard and David Sigler have a vision for Bridger Brewing that involves how the "Old West" can meet the "New West," and it is the beer that will bring the two together.

Dave Breck is no stranger to brewing or the local craft beer scene. Before co-founding Bridger Brewing, he had been a home brewer in Alaska, a brewing assistant at Snowqualmie Falls Brewery in Washington state, a bartender at Full Sail Brewing and he once worked for Todd Scott at the former Spanish Peaks Brewery in Bozeman.

Top: Bridger Brewing is one of Montana's newest breweries, opening in March 2013 adjacent to the Montana State University in Bozeman. *Courtesy of Bridger Brewing*

Bottom: Vigilante IPA is Bridger Brewing's first signature beer. *Courtesy of Bridger Brewing*.

With Breck's experience, along with that of head brewer Daniel Pollard, who came over from Pelican Pub & Brewery in Pacific City, Oregon, the plan is to make a splash on the Bozeman beer scene.

The brewery's first signature beer is the Vigilante IPA, "a hop-forward beer with a good nose," Breck explains. To this they plan to add a total of nine beers on tap.

"We're not really trying to do certain styles right now," says Breck. "We just want to make high quality beer."

On a 10-barrel system, Bridger Brewing is already on pace to turn out about 1,400 barrels, covering about twenty-five different styles, in its first year.

Paired with these beers are "craft pizzas," using freshly ground flour from local company Wheat Montana and all local ingredients and meats, such as bison pepperoni and a variety of in-house sausages. Bridger Brewing sees the creation of fine beer and fine food following the same path.

Eventually the brewery plans to add a canning facility and begin distributing throughout the northern Rockies region.

Red Lodge Ales

1445 North Broadway Avenue
www.redlodgeales.com
Red Lodge (population 2,114)
406-446-4607
Signature beers: Bent Nail IPA, Helio Hefeweizen, Glacier Ale,
 Czechmate Pilsner, Jack's 90 Scottish Ale
11:00 a.m. to 9:00 p.m. Monday–Sunday

When Sam Hoffmann opened the doors to Red Lodge Ales back in 1998, he was only twenty-four years old. His youthful enthusiasm was probably his biggest asset, as he ran the brewery as a one-man-show. He brewed, cleaned, served samples, filled growlers, chatted with the customers and cleaned some more.

For two years, Hoffmann brewed and served beer by himself out of his five-hundred-square-foot brewery, producing just less than three hundred barrels each year. Originally wanting to be a German-style brewery, over the years Hoffmann evolved his beers, and his brewery, into an "everyman's" business.

Red Lodge Ales Brewing Company was not the first brewery in Red Lodge. It is predated by the Red Lodge Brewery that opened in 1910 and produced thirty-five thousand barrels of beer annually. The beer it made was called "Montana Bud." *Courtesy of Red Lodge Ales Brewing Company.*

Hoffmann's desire to brew traditional German beer styles was rooted in both family and personal histories. He grew up in Boston, but his father was from Germany. Hoffmann spent a year himself in Germany while in college and came back to start home brewing.

"Prior to that trip," says Hoffmann, "I was drinking whatever was the cheapest, like most college kids did. Over there I saw what beer could be."

Hoffmann lived close to F.X. Matt Brewing Company in Utica, New York, the second-oldest family-owned brewery in the United States that has been brewing since 1853.

"Sam Adams was relatively new when I was in college, so I mostly drank the *Saranac* beers from F.X. Matt, as well as Old Milwaukee," says Hoffmann.

Hoffmann visited Montana for the first time in 1994 and then moved here in 1996. Working construction in the summers and at the local ski area in winters, the "typical Red Lodge résumé," quips Hoffmann, he quickly realized he needed something more, something less seasonal.

Hoffmann's Red Lodge Ales wasn't the first brewery in that town, however. In 1910, Julius Lehrkind, a German immigrant who stowed away on a ship

at age seventeen in 1860 to avoid the German draft, opened the Red Lodge Brewery with his brother, Fred, in an ornate red brick building at 904 North Brenner, a building that still stands today. The brewery had the capacity to produce thirty-five thousand barrels per year and catered to the local hard-working, hard-drinking coal miners, but it closed by Prohibition in 1918 and later became a pea cannery.

The Lehrkinds, who also owned breweries in Bozeman and Silesia, marketed their Red Lodge beer as "Montana Bud." When choosing Red Lodge as the site for their new brewery, Fred Lehrkind once said, "The chief object that attracted me to Red Lodge was the most excellent water supply here…Without good water, good beer cannot be made."

Having access to good water, as well as good grain, has led to many successes for Red Lodge Ales. In 2009, Hoffmann moved the only brewery in Red Lodge out of its 2,200-square-foot facility and into a 12,000-square-foot one, and he increased his brewing capacity four-fold, now being able to brew eight thousand barrels annually on a twenty-barrel system. The brewery's old seven-barrel system is now used at Angry Hank's Micro Brewery in Billings.

Although at least half of what Red Lodge Ales produces is for draft sales, over 40 percent is packaged in six-packs and distributed in Montana, Wyoming and North Dakota.

Red Lodge Ales' flagship beer is undoubtedly Bent Nail IPA, which accounts for 50 percent of the brewery's beer sales and still remains its fastest growing beer. Hoffmann first brewed Bent Nail IPA in 2001, right as the West Coast IPAs were taking off in the craft beer market. In 2007, it won a Bronze Medal at the Great American Beer Festival.

Hoffmann, who once served as president of the Montana State Brewers Association (now known as the Montana Brewers Association), is committed to buying local as much as possible. He only buys Montana-grown two-row barley from Great Falls (purchasing three hundred thousand pounds annually), and even grows his own hops outside the brewery (though only enough to brew about one batch of beer a year). Beyond that, Hoffmann is also committed to preserving the local community and the environment.

When Red Lodge Ales moved to its new facility, Hoffmann installed a solar array on his building, which at the time was the largest solar unit in the state of Montana, and instead of using energy-intense refrigeration, he uses a Freeaire® Refrigeration unit that draws in the cold mountain air around Red Lodge to cool his beer. Since breweries require a lot of cleaning,

Red Lodge Ales is equipped with a cleaning solution recycler, allowing used solution to be treated and used again. Lastly, to mitigate the use of fossil fuels to transport beer to his regional accounts, he fitted his delivery trucks to run on used grease he collects from the bars and restaurants he delivers to.

For the future, Red Lodge Ales is looking to get into canning, perhaps in the next five to seven years, and the brewery would like to see statewide distribution in Montana, expand into both Dakotas and break into Minnesota. Before then, though, Hoffmann will have to expand his operation again, as he estimates he will be at capacity in the next five years. Not a bad problem to have for a brewery that hopes one day to be brewing twenty thousand barrels a year.

MADISON RIVER BREWING COMPANY

20900 FRONTAGE ROAD, BUILDING B
WWW.MADISONRIVERBREWING.COM
BELGRADE (POPULATION 7,549)
406-388-0322
SIGNATURE BEERS: SALMON FLY HONEY RYE, HOPPER PALE ALE, COPPER JOHN
 SCOTCH ALE, IRRESISTIBLE AMBER, BLACK GHOST OATMEAL STOUT
2:00 TO 8:00 P.M. MONDAY–SATURDAY, 4:00 TO 8:00 P.M. SUNDAY

A common perspective of Montana and its breweries is how both can be enjoyed while recreating outdoors. Perhaps there is no clearer picture of that scenario than the Madison River Brewing Company in Belgrade, a town arguably serving as the state's fly fishing capital. With the world-class blue ribbon Madison River in the brewery's proverbial backyard, it would be hard to imagine the brewery going by any other name. Even the beers express the essence of life in the Gallatin Valley, with Salmon Fly Honey Rye, Hopper Pale Ale and Copper John Scotch Ale—every beer is named for a trout fly. If patrons had their eyes closed in the taproom, it would be easy to feel like they were in a local fly shop instead of an award-winning brewery when hearing these beers being ordered.

But for Madison River Brewing Company owner Howard McMurry, he would probably like it as much to be in a fly shop as he would his own brewery. McMurry bought the brewery in 2004, when it was a contract brewery for Big Hole Brewing (makers of the Headstrong brand), the Moab

Brewery and Park City Brewing. When the brewery originally opened in 1997, it was Lightning Boy Brewing and then it became Great Brewing.

A year after McMurry purchased the brewery, he received a license to brew his own beers, thereby creating Madison River Brewing Company. He stopped contract brewing and "sending truckloads of beer to Utah every two weeks" and started making what interested him. He had been brewing beer since 1996, ever since he got out of college. "It's really all I have ever done or known how to do," says McMurry.

With a fairly aggressive distribution plan, Madison River Brewing beers went statewide within a year, and within three years, they were also sold in Idaho, most of Wyoming and parts of North Dakota. A little later he moved up into Canada.

Running on a twenty-two-barrel system, Madison River Brewing produces nearly seven thousand barrels of beer a year, making it the fourth-largest brewery in Montana. Even at that rate, though, he can't make enough beer to fill his bottles to meet demand.

"My goal is to be bigger than Big Sky Brewing," says McMurry, and Big Sky Brewing currently produces over forty-six thousand barrels annually.

Of the beer he produces, 55 percent goes into bottles, among five different styles, and 45 percent goes into kegs. Still, the brewery's home region is its biggest and best customer, responsible for purchasing 60 percent of what the brewery makes.

A lot of that likely has to do with the taproom McMurry built soon after he got the brewery. He keeps ten beers on tap at a time, with half being his signature beers and the other half seasonals. And like many other breweries in the state, Madison River Brewing has a "mug club" where locals purchase a permanent mug and get it filled at a discount. Unlike other breweries, however, the mugs Madison River Brewing offers are custom, hand-blown glasses produced by Goose Bay Glass of Townsend, Montana.

"We try to let the customer design their own mug," explains McMurry, "and then we go get it made for them as best we can." Each mug costs $100 and holds twenty-four ounces. The mug owners can have two glasses filled per day (to keep within the state's forty-eight-ounce limit), but they only pay the price of three pints, thereby getting the equivalent of one pint free. Though this attention to detail and above-and-beyond approach to customer service may set them apart slightly from some other breweries, being different is not that important to McMurry. What is important is making good beer, standing behind what they make and probably fishing. Fishing is important too.

"A lot of the breweries in Montana make good beer," says McMurry, "so we are really not that different than them. What we probably do differently

is that we make sure every one of our beers is extra special, and that's why not just one of our beers sells well; they all do. Maybe we just have a little more love for our beer, maybe."

So why Montana then? What is great about owning a brewery in this state, according to McMurry? "Montana is just one of the most relaxing places to live in the country."

OUTLAW BREWING

100 SOUTH BROADWAY (INSIDE BAR 3 BBQ)
WWW.OUTLAW-BREWING.COM
BELGRADE (POPULATION 7,549)
406-388-9182
SIGNATURE BEERS: PEACEMAKER PALE ALE, HANGMAN'S JUDGE IPA, IRISH CREAM
 ALE, CHOCOLATE PORTER
11:00 A.M. TO 8:00 P.M. MONDAY–FRIDAY, 9:00 A.M. TO 8:00 P.M. SATURDAY–
 SUNDAY

Very little goes better together than barbeque and beer. That is why Outlaw Brewing may have struck a culinary goldmine when it opened inside Bar 3 BBQ in Belgrade on January 12, 2012. Bar 3 BBQ has two locations, one in Bozeman on North Seventh and the other in Belgrade on South Broadway. Only the Belgrade location contains a brewery.

When Outlaw Brewing was being planned out by husband-and-wife Todd and Nicole Hough, it was decided Nicole should own the brewery.

"I was a stock broker before we opened," says Todd, "and the New York Stock Exchange frowns on brokers being involved in alcohol production or gambling, so my wife founded the brewery. But I'm the brewer."

Todd's original plan was to ride the "housing boom" until he had raised enough capital to start a brewery, but that bubble burst. Instead he went to work for a brewery, cutting his teeth in the industry at Madison River Brewing Company (also in Belgrade) for a few years. He thought he would ride out the storm and come back to the housing market when it rebounded and pursue his dream of opening a brewery.

Serendipitously, as Todd worked at Madison River Brewing, he would find and buy pieces of brewery equipment and store them for his future. Then he met with Hunter Lacey at Bar 3 BBQ, who was looking to add a

Outlaw Brewing is inside Belgrade's Bar 3 BBQ and brews on a 4.5-barrel system. *Courtesy of Outlaw Brewing.*

brewery to his restaurant. Since Todd already had half of the equipment they needed, they found a way for it to work.

For the first year, Outlaw Brewing was using a 2.5-barrel system. Todd has since bumped up to 3.5 barrels. In his first year, he brewed 186 barrels of beer. Along with selling at Bar 3 BBQ, Outlaw Brewing distributes to eight accounts in Bozeman and one account in Billings at the Palms Grand Casino. The Palms Grand Casino is a popular place to fill a growler. It features a diverse selection of local and regional beers since, as a casino, it caters to a diverse, well-traveled clientele.

"Having the small system we do allows us a lot of flexibility," says Todd, "and we can experiment with a lot of different beers and a lot of different beer styles. I also like to say that we brew historically significant beers. I'm not a brewery like Dogfish Head, meaning I'm not out to reinvent the wheel, but if I'm going to make a porter, I'm going to look at the style guidelines for a porter, tweak it to where I like it and brew an outstanding porter."

Todd considers himself a student of beer, especially knowing the history of beers and their styles. "Most beers evolved out of historical events," he says, "and not so much because of taste. I personally like to brew a lot of different European styles of beer, and I think we do them really well."

All the base malt used at Outlaw Brewing is grown and malted in Montana, something that is important to Todd, given that his brewery is in a state with exceptional barley and water. Also important is that his

business protects and supports the local environment and community. For those reasons, Todd sends all his spent grain, along with other compostable material from Bar 3 BBQ, to a local organic farm, resulting in a 75 percent reduction of what the brewery and restaurant typically takes to the landfill.

"Montana is really beginning to have a reputation for its breweries," says Todd. "It's a place where you can take a brewery vacation. Really, what better place is there to visit great local breweries and then drive through places like Yellowstone National Park or over Beartooth Pass?"

As for what is next for Outlaw Brewing, Todd plans to double his production in 2013. Further down the road, he would like to be considered a regional brewery and perhaps get into a canning line. "Ultimately, I'd like to brew three thousand barrels a year instead of three hundred. Getting to that level means I wouldn't have to be a one-man show. I could have a couple people producing this great beer with me. The bottom line, though, is that it's just a great time to own a brewery right now."

NEPTUNE'S BREWERY

119 NORTH L STREET
WWW.NEPTUNESBREWERY.COM
LIVINGSTON (POPULATION 6,969)
406-222-7837
SIGNATURE BEERS: AMERICAN PALE ALE, WHITE DRAGON BELGIAN WHITE,
 CHOCOLATE CREAM PORTER
12:00 A.M. TO 8:00 P.M. MONDAY–SUNDAY

"Don't drink like a fish…drink like a god," is the motto for Neptune's Brewery. Owner Bill Taylor, a former navy diver, first opened the brewery in the basement of Uncle Louie's restaurant in 1996, "back when there were only about five breweries in the whole state," says Taylor. His goal was to be different. Instead of the expected western motif or naming the brewery after a nearby river or mountaintop, Taylor made his brewery to reflect what he loved—the ocean.

"There were plenty of Montana names," says Taylor. "I thought I would change it up. Although Neptune is the Roman god of freshwater, the sea and horses, so I suppose that blends in here."

Before opening Neptune's Brewery, Taylor was pursuing a career in the culinary world, attending classes in San Francisco, but when he came back to Livingston after a serving in the navy it was a brewery that made the most sense.

"Brewing is similar to cooking," says Taylor. "You just work with grains instead." As a start-up brewery working on a two-barrel brewhouse, it was difficult for Taylor to get all the supplies he needed, but he kept his head down and kept brewing.

By 1998, Neptune's Brewery moved out of the restaurant basement into its own location and since it has grown into a fifteen-barrel brewhouse (with plans to be at thirty barrels by the end of 2013). Neptune's Brewery produces about one thousand barrels annually, self-distributing to select accounts in Bozeman and now Gardiner, the north and only year-round entrance to Yellowstone National Park.

Taylor is once again the head brewer at Neptune's, having weathered a few less-than-dependable previous brewers, and that has helped him control his product, keeping it consistent and fresh. Taylor gets constant requests for his beers in Billings but won't look into expanding distribution until he finishes expanding his brewery. He is currently looking into a canning system as well.

At Neptune's Brewery, the beers are traditional and clean tasting, and most are slightly higher than average ABV, falling in the 7–8 percent range. "We try to stay traditional to what the beer should be," says Taylor. "We don't go outside the lines too much." With ten beers on tap at any time, Taylor pulls from his repertoire of sixty beer recipes for whatever he decides to brew next. Perennial favorites include the American Pale Ale (APA), Chocolate Cream Porter and the White Dragon Belgian White.

Though the brewery has served many patrons over its seventeen years in business, and Taylor enjoys living the Montana life, he finds that the brewery business itself can be a challenge, especially with the seasonal nature of the state's tourism. To pay all the bills, Taylor works on the side as a tile contractor and doing construction work. That, however, might change after the pending expansion and being able to move into new markets. Until then, though, customers can "dive" into a sample lineup of Neptune's beers and find out what sets this brewery apart from all the others, aside from the fish tank.

Lone Peak Brewery

48 Market Place
www.lonepeakbrewery.com
Big Sky (population 2,308)
406-995-3939
Signature beers: Lone Peak IPA, Hippie Highway Oatmeal Stout, Nordic
 Blonde
11:00 a.m. to 10:00 p.m. Monday–Sunday (winter and summer hours), 11:30
 a.m. to 8:00 p.m. (off-season hours)

Steve Nordahl, co-founder of Lone Peak Brewery, has been brewing beer commercially since 1992. His first job was for the Frederick Brewing Company in Maryland, which became the new fifty-four-thousand-square-foot Flying Dog Brewery in 2006 after the Colorado-based brewery bought the company.

Steve's appreciation for beer, however, started back in high school. Yes, high school. Steve attended high school in Belgium (where the legal age to buy fermented beverages is sixteen, and those under sixteen are also allowed to drink if an accompanying adult purchases the beverage). When he came back to the United States for college, he attended the Master Brewer program at University of California–Davis.

Steve and his wife, Vicky, always had very strong ties to Montana. In fact, both of their families have lived in Montana for the last 120 years. When the couple decided to open their own brewery, they turned to Big Sky, which was the largest ski resort in the country that did not already have a brewery.

In October 2007, their dream became a reality. When choosing a name for the business, however, Lone Peak wasn't their first choice.

"Big Sky Brewing was already taken," Steve jokes. Instead they named the brewery after the 11,166-foot mountain that casts its snowy shadow on the community of Big Sky. The brewery itself sits at 6,395 feet elevation, nicely tucked between the Gallatin River and Lone Mountain.

Unlike most of Montana's other breweries, Lone Peak Brewery is attached to a brewpub with an all-beverage license, allowing them to be free of the forty-eight-ounce daily serving limit and be open past 8:00 p.m.

Business at Lone Peak Brewery is cyclical. In the summer during fire season it is packed, and in winter when the slopes are open it is packed. During the off-seasons, however, Steve brews mostly to supply the six Montana

distributors that carry his beer and the three North Dakota distributors that do as well. This allows him to flatten out his sales throughout the year.

Steve brews all his beers on a 10-barrel system. In 2012, Lone Peak Brewery turned out 1,300 barrels, but it has the capacity to brew over twice that amount. Primarily draft-only, the brewery does supply limited twenty-two-ounce bottles, but that is a very small part of its business model.

"We really strive to take care of our locals," says Steve, "as there aren't many of them in this small community. We take care of them, and they take care of us. It's like being a big fish in a small pond."

Being a brewery in Montana, according to Steve, is little like a double-edged sword. On one hand, the overall beer culture is good and the customer loyalty is unsurpassable. However, the state's regulations and quota-based licenses, coupled with the fact that getting good statewide distribution is difficult, can be challenging.

"In many Montana bars you walk into," says Steve, "there may be twelve tap handles, but ten of them hardly, if ever, change, so that doesn't leave much room for new beers to come into the market. What this does is inhibits the true creativity of some of the brewers to do special one-off beers because there's limited tap space available for them."

"Especially for smaller breweries like us," Steve continues, "whose business does not revolve primarily around producing, packaging, and distributing two or three flagship beers like larger breweries, it is hard to find the motivation to brew one-offs for markets outside our taproom though we have the time and creativity to do so. It makes it hard to grow and go outside the box."

"As nice as it is for our state to have nearly forty breweries," says Steve, "the fact that a consumer can be in Billings and find only a few beers from Missoula, or vice versa, ultimately makes us way behind in beer culture, and I think the consumers are not getting the fair shake. The 'it's my backyard' mentality can go out the window when we get a more developed beer culture. The question to ask is whether the consumer really benefits by having the same local beer on tap at every bar in their town."

MISSOURI RIVER COUNTRY

MISSOURI BREAKS BREWING

326 MAIN STREET

WWW.MISSOURIBREAKSBREWING.COM

WOLF POINT (POPULATION 2,646)

406-653-1467

SIGNATURE BEERS: BIG BEAVER BELCHIN' ALE, SAND PIKE STOUT, WOLF'S DEN
 WHEAT

7:30 A.M. TO 2:00 P.M. MONDAY, 7:30 A.M. TO 2:00 P.M. AND 4:00 P.M. TO 8:00
 P.M. TUESDAY–FRIDAY, 9:00 A.M. TO 8:00 P.M. SATURDAY (NO BEER SERVED
 BEFORE 10:00 A.M.)

Dr. Mark Zilkoski (Doc Z) never really cared for beer until a few years before
he opened his family brewery. The town doctor for Wolf Point already had
plenty to keep himself busy, with nine children, seventeen grandchildren and
providing his community on the Fort Peck Indian Reservation with medical
services. But one day that changed.

 Doc Z and his wife were watching their grandchildren when she
offered her husband a sip of her beer. "She said, here, you have to try
this Alaskan Amber," says Doc Z. "I did and said, 'Oh my God, that's
good!' But what I found is that you couldn't get a lot of good beers in
Wolf Point at that time, so I started home brewing and inviting friends
over to try them."

For some time, Doc Z could imagine a brewery in his town, but having little business experience to pull it off he turned to friend and now brewery co-owner, Mark Sansaver, who had an MBA from Gonzaga University in Spokane, Washington. The idea still sat stagnant for a while until Doc Z spotted something during a road trip he took.

"I was visiting Lincoln, Montana, in 2007," says Doc Z, "and I found a collection of pint glasses from different Montana breweries. There was one for Harvest Moon in Belt. Belt is a town of six hundred people, and I thought if Belt could have a brewery so could we, so Mark and I put together a business plan and flew by the seat of our pants."

Missouri Break Brewing opened in November 2009, with Doc Z brewing in a forty-gallon kettle. Soon after, he upgraded to a fifty-five-gallon kettle and then into its current 5-barrel system. Annual production for the brewery is about 270 barrels. Nearly everything it brews is served out of the taproom, except for a couple accounts in Scobey (fifty-five miles north) and a local hotel.

The flagship beer at Missouri Breaks Brewing is the Big Beaver Belchin' Ale, a Belgian-style ale made with light Pilsen malt and forty pounds of local Rodenberg honey.

The brewery is also connected to a family coffee shop called Doc'Z, serving breakfast, lunch, smoothies and a full espresso bar.

"We are a family here, literally and figuratively," says Doc Z. "My daughter, Katie, is now the head brewer. Another daughter runs the pub and does the books. My son makes the coffee and serves. My other son serves when he's in town. My sister-in-law does our artwork. It's a family here. And even if you are an outsider, when you walk in, we want to get to know you. Montana is like a family too. Anywhere you go people will want to know about you, and that's what our pub is like."

In the brewery's courtyard, Doc Z grows hops for some of his beers and offers a grill for anyone traveling through who wants to cook their own meal. Each September, he invites the public out to harvest the hops in exchange for a couple pints of beer.

The brewery's plans are to bump up production to about three hundred barrels a year for a few years. Then the family might bottle its Big Beaver Belchin' Ale and Sand Pike Stout.

"I don't want to get too big, though," says Doc Z, "because we might lose the family aspect. This is the place people come to after funerals. It's the place I will open even if I'm closed to host visiting family. It's an oasis where people can come in and relax. It's a lot like *Cheers*." It sounds just like something the doctor ordered.

CHAPTER 7
SOUTHEAST MONTANA

HIMMELBERGER BREWING COMPANY

3008 FIRST AVENUE NORTH
WWW.HIMMELBERGERBREWERY.COM
BILLINGS (POPULATION 105,636)
406-252-1200
SIGNATURE BEERS: WHITEWATER WHEAT, BEAVERTAIL BROWN ALE, CRASH IPA
4:00 P.M. TO 8:00 P.M. MONDAY–FRIDAY, 1:00 P.M. TO 8:00 SATURDAY

Himmelberger Brewing has been around since 1994, but it didn't open its taproom until August 2012, even though getting the state to allow selling pints in taprooms is one of the owner's biggest accomplishments.

Owner Dennis Himmelberger held off opening his taproom because he has been busy serving his community through a four-term career in the Montana legislature, plus adding a couple extra years working behind-the-scenes in state politics.

Back when Himmelberger opened his brewery on Custer Avenue in Billings nineteen years ago, he was a home brewer looking to do something more with his talents. Brewing on a four-and-a-half-barrel system, he started making beers for wholesale accounts around Billings. And as a testament to his beers, most of Himmelberger's current clients today are the same ones he started with back in 1994.

Himmelberger Brewing Company started as a small production brewery in 1994. It did not open a taproom until 2012. *Courtesy of Himmelberger Brewing Company.*

Himmelberger's "boom" years were 1997–98, brewing nearly 350 barrels each of those years, and what he realized was that the craft beer industry was not only going to survive—it was going to flourish. He also realized he needed better control of his product to make a living and to be able to start selling pints to customers. So he worked to change that.

He coordinated with Todd Daniels, who was president of Kessler Brewing in Helena; Tim O'Leary from Kettlehouse Brewing in Missoula; and members of the Montana Tavern Association. They jointly drafted a bill that would allow breweries that produced less than ten thousand barrels a year to sell up to forty-eight ounces of beer a day to an individual between the hours of 10:00 a.m. and 8:00 p.m. Beer sold for off-site consumption (i.e. growler fills) were already legal and not included in this limit.

"That bill passed in 1999 without a hitch," says Himmelberger. "It really flew through legislature. It's important to realize that we wouldn't have what we have today, nearly forty breweries in Montana, without getting this bill passed then."

At the time the bill was being heard, Montana was the last state in the United States that did not allow breweries to sell their products for on-premise consumption. The list of proponents at the bill's hearing included four breweries, the Montana Beer and Wine Wholesalers Association, the Montana Tavern Association and the Montana Grain Growers Association.

That process of working collaboratively with various interests got Himmelberger "hooked" on politics. In 2000, he started working for the state government, and from 2002 to 2010 he served as a member of the Montana House of Representatives, representing the state's Forty-seventh District. He may also have been the only state official during his tenure who had the profession of "Microbrewer" listed on his application.

When Himmelberger served his maximum number of terms, he focused on building up his brewery. He found an old building on First Avenue North, one that was built in 1915, and began remodeling. The new location, interestingly, happens to touch another brewery, Angry Hank's Tap Room (20 North Thirtieth Street).

Himmelberger's new location gives him about six times the space he previously had, and he added a coffee shop, though he has no plans to brew on anything other than his original four-and-a-half-barrel system. He also has no interest in bottling or canning right now.

"We created a very calm atmosphere here," says Himmelberger. The notion of "calm" is something he also puts into his beers. "I try to brew balanced beers for palates," he says. "I don't brew for hype, and I brew primarily session beers."

The highest ABV beer on the menu is the Crash IPA, coming in at 5.2 percent alcohol by volume. Moreover, Himmelberger didn't even brew an IPA until 2013. Instead he has focused on more classic styles. His entire beer portfolio, over the nearly two decades he has been brewing, consists of no more than ten different beers.

Himmelberger sees Montanans as people who appreciate good beer and supporting small, independent businesses, which are the two biggest components that make up a brewery like his, and many others in the state.

MONTANA BREWING COMPANY

113 NORTH BROADWAY
WWW.MONTANABREWINGCOMPANY.COM
BILLINGS (POPULATION 105,636)
406-252-9200
SIGNATURE BEERS: WHITETAIL WHEAT, SANDBAGGER GOLD, CUSTER'S LAST
 STOUT, SHARPTAIL PALE ALE
11:00 A.M. TO 2:00 A.M. MONDAY–SUNDAY

Founded in 1994, the Montana Brewing Company was the first brewpub to open in Montana, which meant it was the only place where food was available for purchase as well as craft beers. The concept was to blend a small brewery, a saloon and a restaurant, with a heavy focus on how dinner and perhaps a dark beer can work well together.

At the time it opened in downtown, Butte was fairly underdeveloped. The brewery's home, however, was an impressive structure. Anchored in the five-story 1914 Montana Power Company building, the Montana Brewing Company gave the structure a much-needed remodel and essentially revitalized the entire downtown district. Today, there are six breweries within walking distance of each other, earning the strip the unofficial name, "Billings Brewery District," and rightfully so, since no other Montana city can claim as many breweries as Billings.

In order to follow state law, the brewery operations are under Billings Brewing Company, the same behemoth brewing operation that was once in business from 1900 to 1951. The restaurant holds an all-beverage license, which is why patrons can choose something other than beer to drink and the establishment can be open until 2:00 a.m. This makes the Montana Brewing Company the only brewery in Billings, and one of the few in the state, that is open after 8:00 p.m.

Another feature that sets the Montana Brewing Company apart is that its beer is only sold at the brewery. It does not distribute to any other bars or restaurants. With a fifteen-barrel system, the brewery produces around one thousand barrels a year, which equates to thirty-one thousand gallons of beer being made and consumed annually within the four walls of the establishment.

The brewery keeps its four signature beers on tap year-round and offers at least another eight seasonals to accompany them. Some of its seasonals are unique, even among national breweries. For instance, it has created a White Stout that is not dark like a traditional stout; it's pale. One of the few lagers produced there is the White Eagle Baltic Porter, with notes of caramelized sugars, dark fruits, coffee and a variety of chocolates. The Beartooth Espresso Porter is made with locally roasted coffee beans. And a perennial favorite at the brewery is the Stillwater Rye.

Patrons are encouraged to try most of the beers on tap by ordering a sample flight. The bartender pours eight small glasses and arranges them on a printed card in the order they should be tasted, typically light to dark, except if a beer is particularly hoppy, like an IPA. Heavy hop flavors can skew the palate and is often saved for last.

The Montana Brewing Company was honored at the 2007 Great American Beer Festival as Small Brewery of the Year.

The brewers at Montana Brewing Company stress simplicity in producing their beers. They try not to use too many specialty hops or malts. This simplistic approach has produced many fine beers, including Whitetail Wheat, an unfiltered American wheat beer with hints of citrus and strawberry. Not only is this wheat beer a top seller, it is the most award-winning beer in the state of Montana.

"Whitetail Wheat has won at least twenty-five awards for us in the last decade," says Sean Graves, owner and general manager of Montana Brewing Company, "including Gold Medals in 2007 and 2012 at the Great American Beer Festival. In fact, as a brewery, we are the most award-winning in the whole state. We have more national awards than all the others Montana breweries combined, and that's pretty special given that our beers aren't even distributed."

Not only have the brewery's beers brought home many major awards, but the brewery itself was also recognized at one of the highest levels. In 2007, the Montana Brewing Company won Small Brewery of the Year at the Great American Beer Festival, beating out 967 other breweries that were nominated in that category.

But not all the brewery's awards are national. For nearly every year it has been open it has won the People's Choice Award for small breweries given out by the *Billings Gazette*.

In 2012, the brewery underwent an extensive remodel. Now when patrons enter the front doors, they get a little "brewery history lesson," with black-and-white photos depicting Billings' long brewing history.

Since the Montana Brewing Company is seemingly set in cruise control at the moment, there are no big plans for change. The brewery does not see a need to get into bottling or canning, nor does it want to start distribution.

"We want fans of our beer to come here for it," says Graves. "It's the only place in the world you can buy it."

CARTER'S BREWING

2526 Montana Avenue B
www.cartersbrewing.com
Billings (population 105,636)
406-252-0663
Signature beers: De-Railed IPA, Black Magic Porter, Ghost Train IPA, Coldwater Kolsch
4:00 p.m. to 8:00 p.m. Monday–Saturday, 2:00 p.m. to 6:00 p.m. Sunday

As co-owner and head brewer Michael Uhrich says, "Carter's Brewing really targets the top five percent of the beer-drinking market. Roughly 75 percent of the market is controlled by Budweiser and Coors, 15 percent goes to the import drinkers, with 10 percent made up of craft beer drinkers. But we're not looking for all of the craft beer segment. It's the top five percent of that group—the beer geeks and a lot of the home brewing community—we try to reach. It's a niche market, but there are plenty of people who like good beer and want to be educated about it. That's who we are after."

Husband-and-wife owners Michael and Becky Uhrich opened Carter's Brewing in July 2007, naming the brewery after their son, who was only

Carter's Brewing is on track to create over one hundred different beers in 2013 and has one of the most diverse beer portfolios in Montana. *Courtesy of Debbie Taillieu.*

eight months old at the time. Previous to opening, Michael had been brewing for the Yellowstone Valley Brewing Company since 2001, one of Billings' three breweries then.

When a building on the historic Montana Avenue came available, he and his wife jumped on the opportunity to launch their own brewery. Carter's Brewing sits alongside the railroad tracks in Billings, which is why all of the beers and décor have a train theme.

Michael thought his brewery could offer the area something a little different than the others, and he wanted to brew the beers he enjoyed drinking. Committed to showing the diversity of beer styles, Carter's Brewing perhaps has one of the largest portfolios of beers in the state, on track to produce over one hundred beer styles in 2013.

"We don't need a reason to experiment," says Michael. "We just need an idea."

Michael brews on a fifteen-barrel system and turned out one thousand barrels in 2012. The majority of Carter's Brewing beers are consumed at the brewery, but the couple does self-distribute to select accounts and works with a distributor to get its beers across the state to places like Missoula, Helena, Great Falls and the Flathead Valley.

Carter's Brewing always has sixteen of its beers on tap; eight are "house beers" and don't change, and the other eight are seasonals or special varietals. The brewery has no plans to get into packaging or to distribute outside of Montana.

"We're trying to not grow too fast," says Michael. "We're more about the product and the education of the product than just producing a high volume of it. It's our way of staying artisanal and having people come to Montana to drink our beer. This has taken us longer to be profitable, but it has given us a very loyal following. People often tell us they think we are at the forefront of the craft brewing scene in Billings."

Billings is also unique in that all six of its current breweries are within walking distance of each other, offering the state's only true "Brewery District." The Billings Chamber of Commerce has even put together a walking map outlining a 1.5-mile route that visits each brewery, a couple historic bars and the city's distillery, Trailhead Spirits.

Angry Hank's Tap Room and Microbrewery

Original: 2405 First Avenue North
Second location: 20 North Thirtieth Street
Billings (population 105,636)
406-252-3370
Signature beers: Anger Management Belgian Wheat, Head Trauma IPA,
 Dog Slobber Brown Ale, Street Fight Red Ale
4:00 p.m. to 8:00 p.m. Monday–Saturday, closed on Sunday

Angry Hank's Tap Room and Micro Brewery has not one, but two locations in Billings. The original location on First Avenue North has a "garage" feel to it, likely because it is a converted auto repair shop. The second, newer location on North Thirtieth Street (next to Himmelberger Brewing Company) is more "industrial chic," with prominent metal, wood and brick features.

Founder Tim Mohr opened his first brewery on Halloween night in 2006 after a couple years of serious planning. Prior to that he worked five years as head brewer for Red Lodge Ales. Since Mohr still lived in Billings and commuted to Red Lodge for work, he had a lot of time to think and dream about opening his own brewery. When he found the right building in Billings, he made his leap.

Mohr's wife, however, was not convinced that his building choice, a former garage and gas station, was ideal. In fact, rumor has it she cried when she first saw the building.

When Mohr and his brother were trying to conceive a name for his new brewery, the two recalled an old family friend name Hank who always seemed grumpy to them when they were kids. Mohr himself was getting frustrated not being able to settle on a name, and his brother said, "Hey, Angry Hank—why not just relax?" and the name stuck.

Mohr self-professes that his brewery is not much different than other breweries in the state. In fact, he claims his is just like every other taproom. However, the crowds that gather every night indicate that whatever he is doing, he is doing it well. Perhaps that is due in part to the fact that Mohr does little distributing and at least 90 percent of all the beer he makes is sold in-house. Mohr also prices his pints affordably, charging three dollars per glass. The idea is that it is always "happy hour" at Angry Hank's.

With his busy crowds, Mohr was able to open his second location in 2012, in a space nearly three times the size of his original brewery. For the time being, the original location will stay open, at least for a couple more years.

According to the Brewers Association, Angry Hank's produced 1,210 barrels of beer in 2012. His top seller is Anger Management Belgian Wheat, followed closely by Head Trauma IPA. Doing something different than other taprooms, however, Angry Hank's does not offer a sample tray or "paddle" of its beers for people to try.

While all the beer names at Angry Hank's may not sound enticing and pleasant, they can surely make a patron feel good.

ÜBERBREW

2305 MONTANA AVENUE
WWW.UBERBREWMT.COM
BILLINGS (POPULATION 105,636)
406-534-6960
SIGNATURE BEERS: WHITE NOISE WHEAT
11:00 A.M. TO 9:00 P.M. MONDAY–SUNDAY

Longtime Billings resident, Mark Hastings, finally got to fulfill his two-decade-old dream of owning his own brewery after meeting local avid home brewer Jason Shroyer. When the two met, Hastings managed one of the city's MacKenzie River Pizza restaurants but had prior experience commercially brewing with Todd Scott when he was at Spanish Peaks

Überbrew strives to make a superlative beer in order to live up to its name. *Courtesy of Überbrew.*

Brewing, then as the head brewer for the Montana Brewing Company from 1994 to 2001, followed by running the temporary Sleeping Giant brewery when it was at a local mall and finally launching into a successful brewery consulting business.

"Jason would bring me home brew samples every once in a while to try," says Hastings, "so we got to talking about a brewery." Hastings and Shroyer then met every Monday for two years hashing out their business plan for Überbrew. Then for another year, they oversaw the construction of their business venture.

On June 18, 2012, their more than one hundred Monday meetings finally paid off and the pair opened the doors to their new brewery. Although unconfirmed, Hastings believes that the building they are in on Montana Avenue was once part of the infamous Billings Brewing Company that operated from 1900 to 1951.

"I would walk by this space, even back when I was brewing for Montana Brewing Company in the 1990s, and dream about having a brewery here," says Hastings.

To set themselves apart in a city with six breweries within walking distance of each other, the founders of Überbrew found their niche would be expertly pairing food and beer, as well as offering a great atmosphere.

"We're going after the 'uber' experience," says Hastings. "From the beverage, food, atmosphere and music, we want to provide the whole package."

Playing off beer "geek speak," Hastings and Shroyer chose Überbrew to reflect the literal meaning of the word. "To us it's the superlative example of its type," says Hastings, "so we are saying we are making superlative beer. Of course everyone says they use the best ingredients in their beer, and we do as well, but we think there is more that goes into a superlative pint of beer than just the ingredients. We think it's atmosphere, service, food and the pairing of those things with beer."

Though some patrons have mistaken the brewery to be of German influence, Überbrew is not exactly that. "We do some German styles," says Hastings, "but not traditional lagers. We do older German styles and ales. We didn't want to be limited by strict style guidelines or the *Reinheitsgebot.* That's why we didn't call ourselves *Überbrau.*"

Überbrew is on track to produce about one thousand barrels in its first year, spread over thirty different styles. It brews on a ten-barrel brewhouse and distributes to select accounts in Billings and Red Lodge, "mostly the places that won't take 'no' for an answer," jokes Hastings.

The emerging contender as the Überbrew flagship is White Noise Wheat, an American style Hefeweizen. The founders hope to have it bring home a few medals in the coming year, as well as bring it to a broader market. In the taproom, however, White Noise Wheat is readily available, along with ten to twelve other "uber" beers.

YELLOWSTONE VALLEY BREWING COMPANY

2123 FIRST AVENUE NORTH
WWW.YELLOWSTONEVALLEYBREW.COM
BILLINGS (POPULATION 105,636)
406-245-0918
SIGNATURE BEERS: GRIZZLY WULFF WHEAT, WILD FLY ALE, RENEGADE RED ALE,
 HUCKLEWEIZEN, BLACK WIDOW OATMEAL STOUT
4:00 P.M. TO 8:30 P.M. MONDAY–SATURDAY

Yellowstone Valley Brewing Company founder, George Moncure, found himself in the right place at the right time when it came to brewing up a passion for craft beer, being from the Fort Collins area of Colorado around

the time the local home brew club, the Mash Tuns, was playing host to the humble beginnings of the New Belgium Brewing Company.

Moncure was there, "hunkered down in the basement" of New Belgium's co-founder, Jeff Lebesch, trying to fill bombers of his home brew. Moncure went on to pursue studies in chemistry and geology, and beer became his academic hobby.

At one point, he and a partner had fairly firm plans to open a brewery in Steamboat Springs, Colorado, but the idea was trumped when a recent lottery winner decided to beat them to the punch and open her own brewery there before they could.

Moncure's consulting work took him to Montana frequently, working on projects like the Milltown Superfund Site outside of Missoula and various projects in and around Billings. When an opportunity came up to open his own consulting office in Billings, he took it, "but I did so with selfish thoughts," says Moncure, "because I thought there wasn't much going on with brewing there yet so I could fall back on that if I wanted."

But there was something brewing in Billings then. The original Himmelberger Brewing Company had begun in 1994 and was brewing very small batches. Moncure had visions of something a bit larger.

By 1996, Moncure and a partner found the funds to start their own brewery, and the brewery's first batch rolled out in 1997. Today, Yellowstone Valley Brewing Company brews nearly two thousand barrels a year.

"It was a really hard way to do a brewery," says Moncure, "because Billings didn't fit the model of a craft brewery town. We had to educate our customers. It was completely different than Colorado." Early patrons often asked if what they were doing is like what Henry Weinhard produced, as that was their prevalent association with craft beer.

When coming up with the name, Yellowstone Valley Brewing Company, Moncure went with a reference everyone knew—Yellowstone—even noting that it "brews from the waters of the 692-mile undammed Yellowstone River and ferments in the shadows of the majestic Beartooth Mountains."

"We made a mistake though," says Moncure. "We made the name too long. We never should have put in 'Valley.' It's hard enough to get neon just with the word 'Yellowstone' in it!"

Starting out, Moncure brewed his beers on a fifteen-barrel system, the same he uses today, which is the size he learned on hanging around Odell Brewing in Fort Collins.

He set up immediate distribution throughout eastern Montana, South Dakota, North Dakota and parts of Wyoming, but he found it much harder to move into the western parts of Montana. Not just sticking to draft beer, though, Moncure bottled his beer from day one.

"We knew bottling would be very important," says Moncure, "so we did that immediately."

In 1998, the brewery's second batch of Black Widow Oatmeal Stout won a Gold Medal at the Great American Beer Festival.

With award-winning beer and distribution in place, Moncure was in the position to do something else unique to the Billing craft beer movement—open a taproom. Not part of his original plan, Moncure was convinced by his friend Ed Kinneck, who wrote for the *Billings Gazette*, because he wanted a place to play music.

Since 2001, "The Garage" at Yellowstone Valley Brewing Company has been a hot spot for musicians and touring bands.

Still seeing room for the Billing beer scene to grow, Moncure founded his side project, Bones Brewing (1425 Broadwater Avenue), in 2008 with the help of longtime friend and director of the Judith River Dinosaur Institute director, Nate Murphy.

Murphy, who hunted dinosaurs with legendary paleontologist Jack Horner, came up with the name in about ten seconds after hearing of Moncure's plans to open a smaller brewery. Montana has a rich, 175-year history as one of the greatest places in the world to find dinosaurs. In fact, one of the first Tyrannosaurus Rex skeletons was found in the Hell Creek Formation near Jordan, Montana, in 1902.

Bones Brewing is another place for craft beer and live music, two of Moncure's favorite things. Brewing on a ten-hectaliter system allows the brewery to produce smaller batches and offer a "beer of the month." In addition to serving up Yellowstone Valley Brewing beers, the brewpub also features brews like Sharptooth Organic Peat Smoked Porter, Bonehead Ale and Numbskull IPA.

Perhaps most notable about Bones Brewing, however, is that Moncure learned from his "mistake" and went for a shorter name, one easier to put in neon.

Fat Jack's Taproom

317 East Main
Laurel (population 6,814)
406-530-1762
Signature beers: Honey Porter, Morgan's 90 Schilling Scotch Ale,
 Belgian White, Brim Buster DIPA
4:00 p.m. to 8:00 p.m. Monday–Saturday

In a roundabout way, Fat Jack's Taproom got started out of boredom, at least the way Mike Solberg tells the story.

"When my father, Steve Solberg, retired from selling Ford vehicles and sold his dealership in 2009," says Mike, "he got bored in about four months, so he opened the brewery with a local home brewer, Levi Bequette, to whom he had sold a car recently and who sparked the idea of a Laurel brewery." Steve and Levi opened the brewery together in December 2010 in a vacant building they remodeled.

Bequette's first brewing experience was when his father redeemed a gift certificate to Kettlehouse Brewing Company in Missoula when it was still a "brew-on-premise" business. He was only in high school then, so he could not sample his father's finished product. Years later, Bequette and his wife moved to Fairbanks, Alaska, where his wife bought him a two-and-a-half-gallon homebrew kit. It was not long before he moved into a five-gallon brewing system and eventually had a twenty-gallon custom system built by a family friend.

One of the more interesting facts about Fat Jack's is that it is not named after a large man named Jack. Instead, for a reason not shared with the general public, it is named after Steve's longtime college friend, Bruce, who is quite slim.

Laurel is a railroad town, and the taproom décor reflects that. From using a sliding box car door between the bar and taproom to a 125-year-old rail that serves as a food rest at the bar, the brewery is a reflection of its community, and the community is now part of the brewery, in a literal sense.

After fifteen months in business, Fat Jack's brewer, Levi Bequette, left to pursue a more lucrative career in the Bakken oil fields. This left a large and immediate hole in the business. That is when Steve's son, Mike, stepped in and learned to brew in about four weeks. Needing more experienced "hands in the kitchen," Mike turned to the local home brew community and invited them in to brew on the brewery's seven-barrel system. Now every Sunday

is "brew day," with up to twenty home brewers coming in to volunteer. The taproom provides lunch in return, and the brewers get to have their beers featured in the taproom.

"If the recipe was good," says Mike, "we'd keep it on tap." They have since brewed scotch ales, a Belgian white, Imperial IPAs and many others. In fact, in the last year, Fat Jack's has turned out twenty different beers but now keeps six regular beers on tap. Most of the beer is sold in-house, though Mike does self-distribute as far out as Billings, eighteen miles away.

"Although we don't have any of the same beers now that we started with," says Mike, "we try not to change up our beers too much because Laurel, as a whole, is a creature that does not like change."

"What we can do here, in addition to make good beer," continues Mike, "is focus on good service. We bring people beer instead of making them come to the bar and get it. Chances are if you are in here once a week, we'll have a beer poured for you before you even sit down. We make it personal and get to know you by name."

As a brewery, the goal for Fat Jack's Taproom is to be on tap at another dozen establishments and to have a signature "Laurel beer."

"We want to have the beer that when someone comes into town it is the one everyone recommends to you," says Mike. "We want something like Cold Smoke is to Missoula. That's a pretty steep order, but that's our goal."

Beaver Creek Brewery

104 Orgain Avenue
www.beavercreekbrewery.com
Wibaux (population 571)
406-795-BEER (2337)
Signature beers: Redheaded IPA, Wibaux's Gold, Rusty Beaver Wheat, Paddlefish Stout, Beaver Creek Pale Ale
4:00 to 8:00 p.m. Thursday–Sunday (open 2:00 to 8:00 p.m. on Saturday and Sunday during summer.)

Perhaps Montana's only true "destination brewery," as in it's the only craft beer destination on the six-hundred-mile stretch of highway between Fargo, North Dakota, and Billings, Montana, Beaver Creek Brewery is an

apt reflection of Montana's historic breweries, where town and brewery are inseparable.

Named after the cottonwood-lined Beaver Creek, where the trees are older than the town cemetery, the brewery is a centerpiece of Wibaux (population 571). To reflect its broad appeal to both locals and tourists, Beaver Creek Brewery thrives on two mantras: "If You Brew It, They Will Come" and "Our Beaver Tastes Better!" according to owners Jim Devine, Russ Houck and Sandon Stinnett.

Jim Devine and Sandon Stinnett (who is credited by Jim with doing 99.9 percent of the brewing) are friends and former home brewers. One too many times they had friends swing by on bottling and kegging days looking for a pour or asking them to provide beer for a wedding, so they decided to take the plunge and put their passions and talents to the test.

They opened the brewery in August 2008 after investing eighteen months and four thousand hours of after-hours "sweat equity" renovating a 1914 Wibaux grocery store that had been vacant for over twenty years.

Rolling out on a 4.5-barrel system and seventy-five kegs they salvaged from the former Milestown Brewing Company of Miles City, the brewery has since undergone four expansions and now brews on a 10-barrel system to keep up with increased demand.

"It took us eight months to get a plumber out here," says Jim Devine. "We couldn't get anyone to show up, but ultimately we prevailed."

With only one beer on tap when it opened, Wibaux's Gold, which Devine calls a lager-style ale brewed with honey and aimed at converting the macro-beer drinker, the brewery has since created sixteen different beers and in 2012 brewed 771 barrels, nearly a 300 percent increase since 2009.

"For comparison," Devine jokes, "Sierra Nevada still brews twice as much beer in one day than we do in a year."

Beaver Creek Brewery distributes its beers from Billings to Bismarck, and as far north as Williston, North Dakota. In 2009, at the inaugural Montana Brewers Association Brew Festival in Bozeman, Redheaded IPA took home the People's Choice Award.

"What we have going for us is that we are either the last brewery travelers hit as they leave Montana heading east or the first one they reach coming into the state," says Devine. "And now we've been around long enough to hear all the 'pleasantly surprised' stories from people who thought we wouldn't last."

INDEX

ABOUT THE AUTHOR

Ryan Newhouse moved to Montana in 2002 for graduate school and has yet to find a reason to leave. He works as a full-time freelance writer, covering a wide variety of subjects, but he always prefers writing about beer. This is his first book. In his free time, he helps raise his two children and gets out to explore the woods, rivers and mountains as often as possible.

Ryan has nurtured his appreciation for craft beer one glass at a time and sometimes he falls in love with a style more than once. He writes for several beer blogs, including his own, MontanaBeerFinder.com. He is a co-founder of Missoula Craft Beer Week, and he thinks his German heritage has a lot to do with his admiration for beer.

Visit us at
www.historypress.net

· ·

This title is also available as an e-book